POSTCARD HISTORY SERIES

Harrisburg

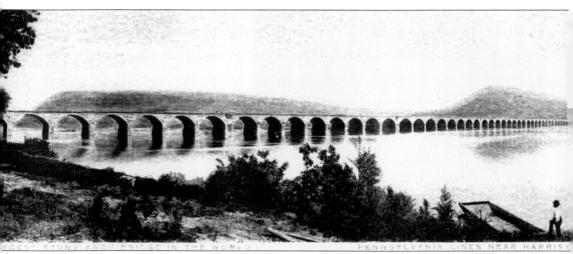

The majestic sweep of the Rockville Bridge above Harrisburg provides an impressive panorama of the Susquehanna in 1902. Looking down river on the old highway below Dauphin, the bridge is perched 46 feet above river level. Its 48 stone spans total 3,820 feet with a width of 52 feet to accommodate four rail tracks. Rockville Bridge would be among the many magnificent sites one journeying Dauphin County would encounter. (Courtesy of author's collection.)

On the front cover: Swift and Company at 700 Seventh Street took advantage of Harrisburg's strategic distribution capabilities. Serviced by seven rail companies at its industrial core, all types of manufacture located here. From the days of the canal to international air transport, Harrisburg has played a big part the country's growth. (Courtesy of John Curtis Lee Tackitt collection.)

On the back cover: Fire Chief John C. Kindler sits at the wheel of this 1913 Studebaker Flanders runabout with his assistant Chief Edward Halbert, on Front Street. Painted red, it was augmented with emergency equipment. Hope Station on Second Street was its home. Note that this 25-horsepower car has a right-hand drive. (Courtesy of author's collection.)

POSTCARD HISTORY SERIES

Harrisburg

Jeffery Adams

ARCADIA
PUBLISHING

Published by Arcadia Publishing
Charleston, South Carolina

Printed in the United States of America

Library of Congress Catalog Card Number: 2008930907

For all general information contact Arcadia Publishing at:
Telephone 843-853-2070
Fax 843-853-0044
E-mail sales@arcadiapublishing.com
For customer service and orders:
Toll-Free 1-888-313-2665

Visit us on the Internet at www.arcadiapublishing.com

To Rhoda Burns Adams, 1925–2008.
She would have been thrilled with this book.

CONTENTS

ACKNOWLEDGMENTS

Much of what we accomplish in life would not be possible without the assistance of others. This book lends truth to that statement. I would like to acknowledge the great help author David W. Houseal afforded in setting me in the right direction and Ken Frew of the Dauphin Historical Society for the many anecdotes on history he provided. C. Robert Chinnici deserves accolades for putting up with the intrusion of 3,000 postcards and volumes of paper and publications strewn about our library. I would like to thank Lisa Bauer for her constant interest and encouragement during the progress of my various projects. An old friend, Michael J. O'Malley III, editor of *Pennsylvania Heritage Magazine*, was an early inspiration in my pursuits. Mary Weigle Whelan help me get established when I moved to Harrisburg, and for that I am truly thankful. What is common among those mentioned here is the enthusiasm shown for the history of Harrisburg. My immeasurable gratitude goes to all of you.

I also wish to thank my editor at Arcadia Publishing, Erin Vosgien, for her expert guidance. Those who love history truly benefit from her abilities.

Unless otherwise noted all images are from the author's collection.

INTRODUCTION

At the beginning of the 20th century, Americans held dear the simple and the beautiful. A treasured gift may have been a hand written poem, a sketch, or a letter. When friends stopped by, these tokens were shared. The front parlor chairs were drawn around the center table and photographs, shells, and stitched handiwork became an evening's points of discussion. At the same time, a simple paper item was evolving due to new developments, sending it on its way to mass popularity.

In 1898, Congress passed the Private Mailing Card Act, which allowed private firms to produce cards that could be mailed. Previously the United States Postal Service was the only one permitted to print mail-worthy cards. These previously hand-carried souvenirs could now be placed in the mail and become a welcomed gift. With the introduction of the folding pocket camera in 1906 by Kodak, these mailings became more personal. The photograph processor had the ability to finish the back for mailing. Photographs of loved ones and images of proud homes and pets were now placed in special velvet albums along with the hundreds of cherished penny cards sent by friends and relatives.

These developments parallel the events taking place in Harrisburg, Pennsylvania's capital city. Harrisburg was approaching 200 years as a settlement. The streets remained unpaved and the century old buildings were showing their wear. This was all about to change because of an event borne out of tragedy. But first, it is important to see how we got to this point.

Harrisburg is located at a juncture where Pennsylvania's Great Valleys meet on a fertile plain in south-central Pennsylvania. The setting is on the wild and scenic Susquehanna River. Its founder, John Harris, came to this isolated territory as an associate of William Penn at the founding of the commonwealth. Harris sought a living on the banks of this mighty and challenging river on America's western frontier. He established a ferry landing that opened up the vast Cumberland Valley on the opposing shore. A growing nation's most important passage westward was in view of this future city.

John Harris Jr. followed his legendary father. He laid out a borough before the arrival of its citizens. He petitioned for this district to become a county, Dauphin. Subsequently he coaxed the legislature of the commonwealth to relocate its government to his growing, centrally located community. Acres of land on a hill north of his town were reserved for a governmental district. In 1812, all was realized with the arrival of legislators from the east.

But the younger Harris did not forget the Susquehanna, Harrisburg's defining entity. The first bridge to cross this river was constructed, and in years to come, more distinctive bridges would join the original, making Harrisburg the object of many outstanding images produced worldwide.

If any city's development mirrored that of the country's growth, Harrisburg is a fine example of this parallel course. The Civil War, the explosion of the transportation industry in the mid-1800s, and the industrial revolution all helped shape this city. Additionally Harrisburg was not only central to the commerce of the region but also had the distinction of having the government of one of the nation's most powerful states operating in its midst.

The building of the Pennsylvania Canal was significant in the development of the commerce of this growing city. For the first time, enough revenue was being generated by goods brought to Harrisburg for distribution that investors established banks. Loans were available for industry to build along the canal and in turn take advantage of its ability to distribute finished products. Within a few years, the more efficient railroads followed the same path and bolstered Harrisburg's economic growth. They chose this city as a base of operation that had a far-reaching economy.

It was an early decision that preserved Harrisburg's most valuable resource, its now pristine riverfront. A choice to follow a smaller Paxton Creek, which ran through the interior of the borough, as opposed to placing towpaths along the Susquehanna River prevented industrial blight. This preserved the face of a beautiful city for future generations.

However, an ironic tragedy caused a chain of events that brought national attention to Harrisburg and created a movement that was felt across the country. A fire destroyed Pennsylvania's capital building one winter's morning in 1897. The subsequent rebuilding project sparked a social as well as political campaign known as the "City Beautiful Movement."

Every segment of the city began a transformation incorporating public art, miles of park development, and paved streets. A few distinguished citizens gave speeches and lent their effort to show that cities in Europe of like size had taken their natural settings and transformed open land and streams into parks and landscaped pathways. Among these developments, investment in the community from business leaders and the attraction of new commerce helped change Harrisburg's appearance. This momentum continued for some 30 years and saw a total rebuilding of the city's substructure. It also inspired a later generation suffering from late-20th century urban decay to look back and restructure with much of the same spirit.

The crowning glory of Harrisburg's achievements is the capitol building that John Huston built and was dedicated to the commonwealth in 1906. This astounding building and the grounds of the surrounding campus have become a park with a growing collection of distinctive buildings that support our government.

Thus Harrisburg has become known internationally as a first-rate convention city. Its clean streets, miles of cultivated parks, and the phenomenal use of its natural waterways have been a benefit to commerce and tourism. The sports venues, museums, and entertainment centers have been a boon to the local economy.

The introduction of the postcard and the rebirth of Harrisburg took place at the same time. Each new building, and every event to celebrate an achievement along the way, was recorded for prosperity by the postcard. It could be that the civic pride generated by the images of this progress may have added momentum to the movement. And the benefactors have been the people who call this city home. The beauty of this vibrant city is theirs to enjoy, and for this, they take great pride.

One

OLDE HARRISBURG

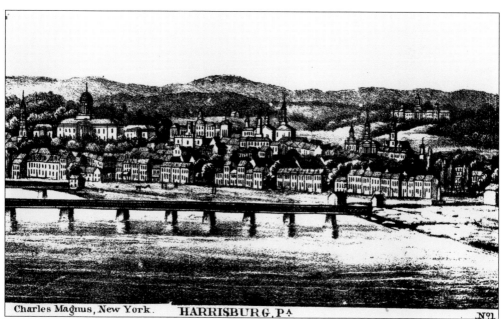

Charles Magnus, New York. HARRISBURG, PA No1

Prior to the introduction of the postcard, businesses often used "covers" to convey their message. These were simply letters with the edges folded over to form an envelope. At times, a cover might present an image. This Charles Mangus woodcut depicts Harrisburg prior to 1855. Market Street Bridge dominates the foreground. This city of steeples perched on Front Street hill is not much more than four blocks deep.

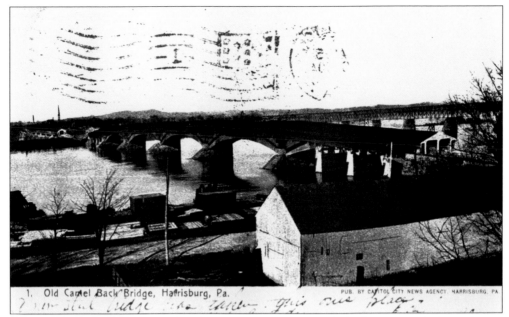

1. Old Camel Back Bridge, Harrisburg, Pa.

PUB. BY CAPITOL CITY NEWS AGENCY, HARRISBURG, PA.

In 1809, the state's general assembly authorized the construction of a bridge to cross the Susquehanna River at Market Street in Harrisburg. This first crossing of the mighty river would be a major undertaking. An enclosed wooden pathway accommodating many sorts of travel was completed in 1817, under the direction of Theodore Burr. Lasting most of a century, this toll bridge lost a final battle in 1902 to a flood.

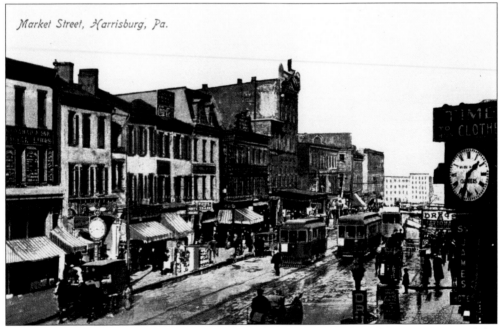

Market Street, Harrisburg, Pa.

Issued after 1907, it is evident that this Market Street image represents an earlier era. No automobiles appear, however the horseless streetcars dominate a two-track system. Wonderful advertisements abound. For five cents, one could get their shoes shined or their hat cleaned. Awnings attached to early 19th century buildings ease a shopper's browse along the crowded street.

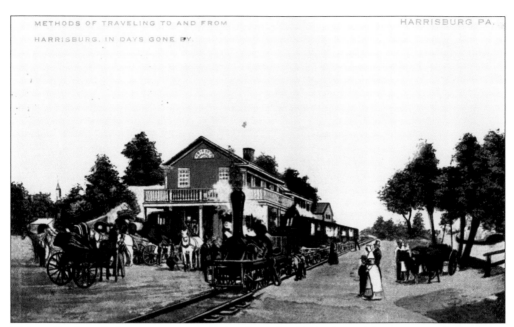

This stylized rendering was a popular print from the 1890s. Later it became a well-circulated postcard. Shown are methods of transportation that would have been familiar in the 1830s. The depot is typical of the period having served as an inn. A puffer belly-steam engine pulls a line of coaches. An oxen cart rests in view of a passing canal boat. Various conveyances, including the ubiquitous Conestoga wagon, await passage.

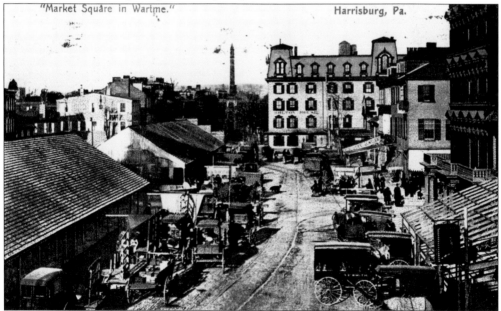

Around 1907, a popular photograph card began circulating showing Market Square in a bygone era. Titled "Market Square in Wartime," it was actually of a period closer to 1880. Nonetheless it is an important glimpse of a true urban market setting of the 19th century. Plans were afoot to encourage food vendors to vacate the square. Market houses established in various neighborhoods provided a more organized outlet for food distribution.

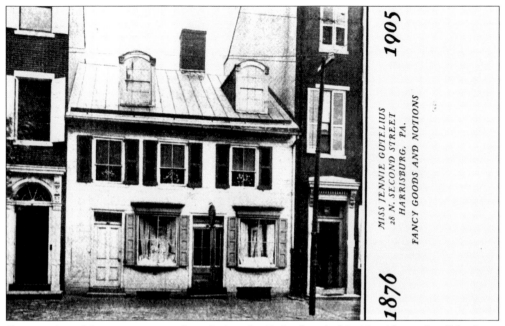

MISS JENNIE GUTELIUS
28 N. SECOND STREET
HARRISBURG, PA.
FANCY GOODS AND NOTIONS

1905

1876

Shops such as this were commonplace during the Federal period in Harrisburg. Small business establishments occupied the street level. A door on the left led to the shopkeeper's dwelling above. Jennie Gutelius specialized in fancy goods and notions at 28 North Second Street. In 1905, she was celebrating her 24th year of business in this nearly century-old building. Unfortunately progress would shortly claim this block of merchants.

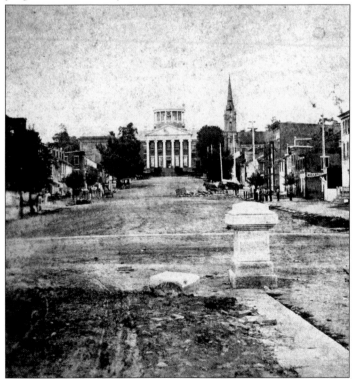

The entrances of the old state house each faced a distinctly different audience. The western portico looked on law offices, churches, and desirable homes progressing to the river. The eastern face, shown here from State Street Bridge, stood guard over old eighth ward. Blue collar workers lived in tight quarters forming the basis of city life near the canal and railroad. Eventually the capitol complex expansion would consume this entire district.

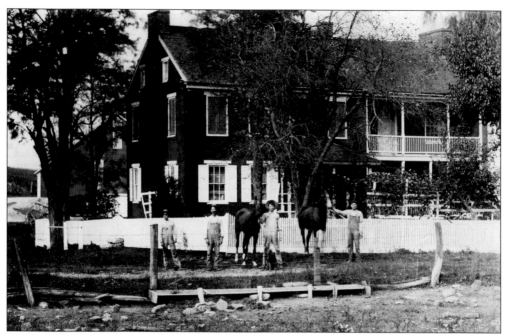

The townships and villages that encompassed old Harrisburg were largely agrarian. Highly productive farm land was found to the east and south. Many homesteads were occupied by the same family for generations. Grandparents often shared quarters with an extended family. These lads with their papa have Lillybelle and Mr. Charles recorded on this postcard for posterity. Shutters drawn upstairs indicate a temperate day was in the making.

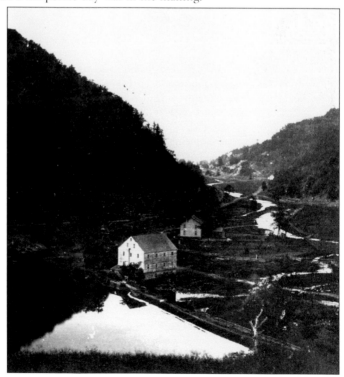

This view of McKees Gap illustrates the geography as seen when settlers traversed westward to the Susquehanna River. Harrisburg sat on a high bank, the river relatively unobstructed. However, areas up and down the river were separated from the Susquehanna River by water gaps. The rim of the Great Valleys formed these natural outlets where tributaries drained into the river. Small industries, such as flour mills, found these locations ideal.

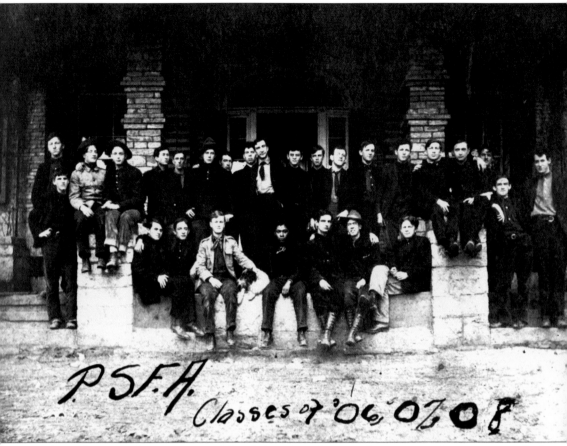

Harrisburg was home to many ideas being shaped across the country. A new century had begun, and an awareness of responsible land use was becoming a reoccurring theme in the press. In Harrisburg, J. Horance McFarland and Mira A Lloyd Dock sparked the "City Beautiful Movement." Gifford Pinchot, a future governor of Pennsylvania, became America's first chief of the U.S. Forestry Service. Four U.S. presidents found use for him in their administrations. Under the patronage of Teddy Roosevelt, he worked to influence the public to preserve natural resources. Pinchot coined the phrase "conservation." Joseph Rothrock, an environmentalist, was the "Father of Forestry" in Pennsylvania. He led the drive for Pennsylvania to purchase millions of acres of woodlands from lumber companies to create the pristine state park system. "Unless we reforest, Pennsylvania's highlands will wash into the oceans," warned Rothrock. Here Rothrock's first graduating classes can be seen at Mount Alto Forestry School, now under the jurisdiction of Pennsylvania State University. Please note the country's first African American forester, class of 1906, Ralph Edward Brock, front row, center.

Two

HARRISBURG, A CAPITAL IDEA

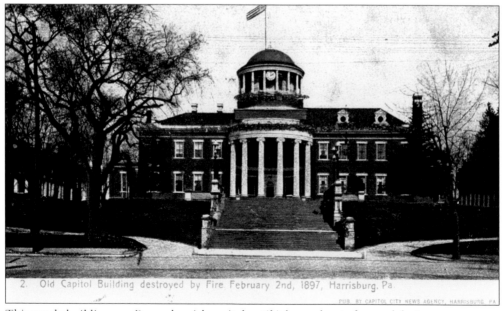

2. Old Capitol Building destroyed by Fire February 2nd, 1897, Harrisburg. Pa.

This stately building was Pennsylvania's capitol until it burned out of control during a snowstorm on Groundhog Day, February 2, 1897. Known as the Hills Capitol, Steven Hills, architect, along with 80 workmen formed a procession that led the legislature to its new home in 1822. The next 75 years witnessed Pennsylvania's growth to become the nation's industrial giant as the Hills Capitol served reverently as its seat of government.

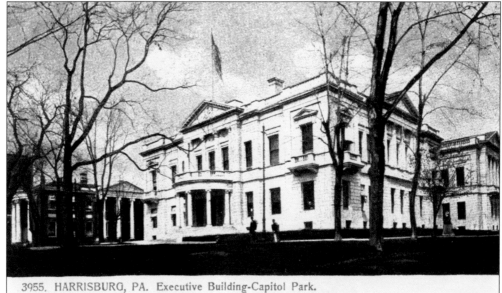

3955. HARRISBURG, PA. Executive Building-Capitol Park.

The executive building is shown next to the capitol in the 1890s. Built in 1894, this Italianate Renaissance–style manse exists as the oldest at the capitol complex. The capitol had reached capacity, so a multi-use annex became necessary. The state library was located here. Additionally historical artifacts gathered here gave birth to a state museum. When laws mandated archival of public records in 1903, this was the first repository.

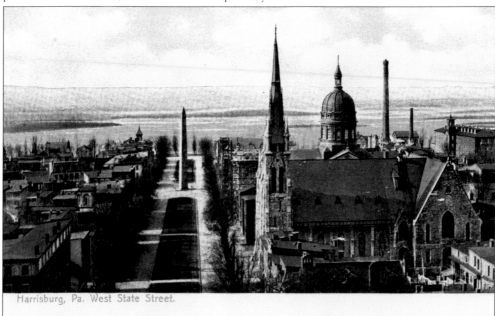

Harrisburg, Pa. West State Street.

During the fire of the capitol in February 1897, the legislature was in session. Quickly forced to evacuate, the law makers reconvened in the Grace Methodist Episcopal Church in this image on the right. This West State Street location remained the house of Pennsylvania's government for an extended period while the drama of replacing the capitol played out a half block away on the hill.

This gentleman was in Harrisburg visiting the construction of the new state capitol when he posed on the plaza in 1900 for this photograph. He is facing the nearly completed Cobb Capitol. Legislature approved the building of a new, more modern structure after the dismantling of the ruins of the old brick Hills Capitol edifice. This plaza overlooking State Street would serve as official entrance for three state capitol buildings.

Few photographs exist of the short-lived Henry Ives Cobb–designed Pennsylvania State Capitol. The mortar had barely dried before a public outcry decreed this as unworthy of Pennsylvania. Editorialists likened it to a college gymnasium. In 1901, another architect was sought. Cobb had been secretly instructed by legislature to make his building functional but not complete. Funds were accruing through state-owed debts that were now being recovered.

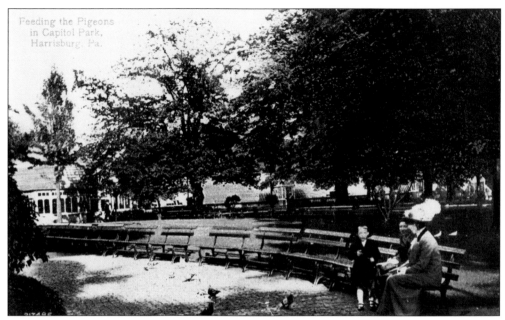

Feeding the Pigeons in Capitol Park, Harrisburg, Pa.

The implementation of Cobb capitol had thwarted pressure from Philadelphia to move the seat of government. The legislature, sure of its financial ability to provide a worthy replacement, began a design competition. They sought a Pennsylvania-born architect with a vision of majesty. Joseph M. Huston delivered an appropriate proposal. This happy group near the Capitol Park greenhouses, erected in 1891, seems oblivious to any troubles in Harrisburg.

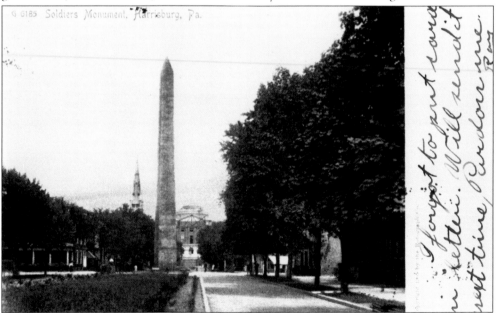

G 6185 Soldiers Monument, Harrisburg, Pa.

Construction of the new capitol building commenced in 1902 under the direction of architect Huston. When the grand entrance was about to be constructed, a cornerstone ceremony took place in May 1904. Shown from Front Street is the uncompleted capitol building. A dome is beginning to rise beyond the right of the Soldiers Monument. A new cathedral would soon appear on the left above Second Street.

The Dauphin County Soldiers Monument was a constant reminder of the soldiers who gave their lives to preserve the Union. This plain and lofty shaft of Susquehanna granite towered in the middle of Second Street. Its assembly began in 1867 by E. Worall Hudson, paid through public subscription. It took shape as the funds became available. Increasing automobile traffic required that it be removed to Division Street in 1959.

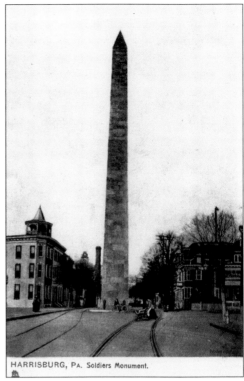

HARRISBURG, PA. Soldiers Monument.

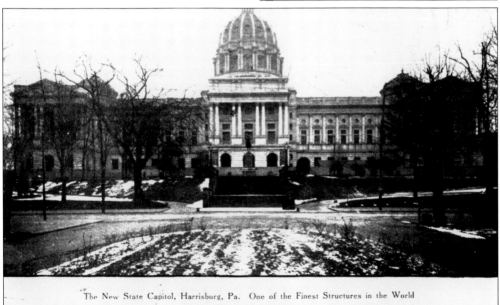

The New State Capitol, Harrisburg, Pa. One of the Finest Structures in the World

October 4, 1906. President Roosevelt will be here

The public had watched with anticipation for over four years until the interior had been completed. The crown jewel of the commonwealth stood on the hill covering over two acres of ground. The total cost for building and furnishing the capitol was $13 million. Faced in Vermont granite and deigned in the classic renaissance style, this project was modeled after the U.S. Capitol and classical buildings in Europe.

19

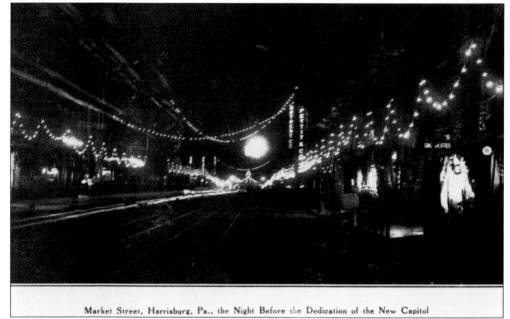

Market Street, Harrisburg, Pa., the Night Before the Dedication of the New Capitol

With the on-going public works projects taking shape in the capital city, there were frequent ceremonies in the first quarter of the 20th century. The premiere event by far was the new capitol dedication. The evening of October 3, 1906, saw the city of Harrisburg illuminated with strings of electric lights encouraging businesses to remain open late. Over 50,000 invited guests using special Pullman cars congested the train stations.

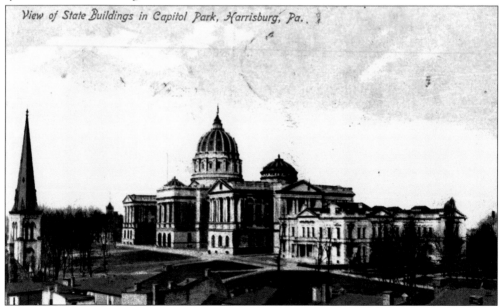

View of State Buildings in Capitol Park, Harrisburg, Pa.

A view of the Pennsylvania Capitol Building with the executive office building on its right is shown shortly after the dedication festivities from a Walnut Street perch. Gov. Samuel W. Pennypacker had greeted a crowd numbering into the hundreds of thousands. Third Street for blocks and State Street to the river was awash with people. The guest of honor was Pres. Theodore Roosevelt. Afterwards he visited with the governor's family on Front Street.

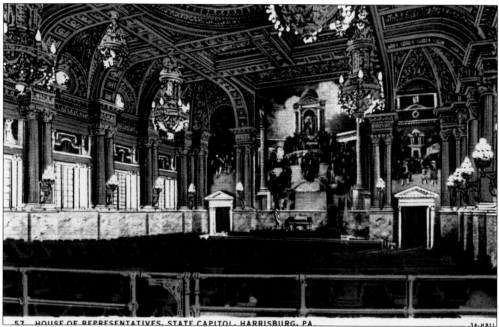

57. HOUSE OF REPRESENTATIVES, STATE CAPITOL, HARRISBURG, PA.

Joseph Huston utilized painting, sculpture, and architecture to "symbolize and glorify the Commonwealth." His accomplishment contained 600 rooms all furnished and decorated to explicit plans. Murals were painted by Violet Oakley and Edwin Austin Abbey, celebrated artists of the period. A stroll through the building would take hours if one focused on the art. The story of Pennsylvania is retold through every detail. Some 16,000 square feet of finely crafted Moravian tile, hand cast by Henry Mercer, pave the Grand Hall. No museum in the country boasts a collection comparable to this. Huston's studies in Europe and his fascination with American History become evident. This personal tribute to the commonwealth is an amalgamation of classical styles with a truly Pennsylvanian theme. The most extraordinary building in the nation sat squarely in the center of Harrisburg.

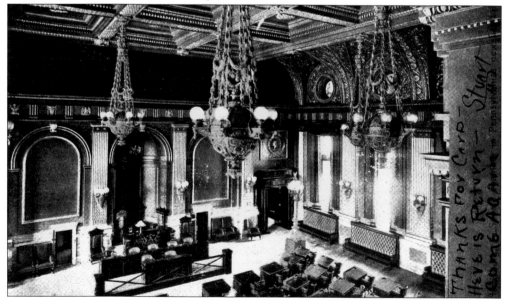

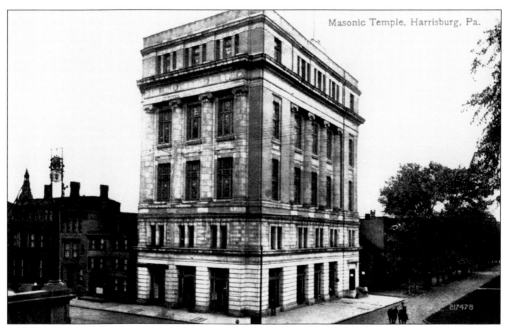

Masonic Temple, Harrisburg, Pa.

The year 1906 was the year that the license plate debuted in Pennsylvania; however, it would seem that automobiles were still a bit of a novelty. A lone horseman leads a riderless steed home, possibly from an equestrian event on Forster Island. The Masonic temple was under construction opposite the new capitol on State Street at the same time. Note the globed arc lamp on the wall on left at the capitol entrance.

Feeding the pigeons in Capitol Park, Harrisburg, Pa.

A traditional place for day workers to catch a breath of air is Capitol Park. Bound by Walnut and Third Streets and covering the grounds of the capitol complex, the park has been a respite for day workers for generations. Part of John Harris Jr.'s original plan for the legislative district, this was outside of Harrisburg Borough until consolidation brought the tract into the borough's jurisdiction in 1838.

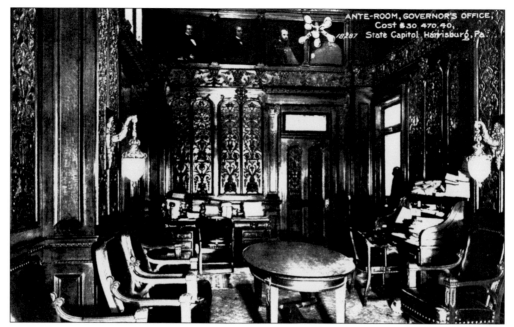

A series of cards were produced in 1907. Each focused on the price of a particular object or room. This example shows the governor's anteroom totaling $30,470.40. The expected cost of the total project was $4 million. The final price exceeded $12 million according to auditors. State bookkeeping practices were poor, so attention was not paid to accurate accounting. Charges of graft were leveled against architect Joseph Huston for mismanagement.

It was in this private cloister in Germantown that architect Huston formulated many of the now celebrated details for the Pennsylvania Capitol Building. This rare personal-use postcard was discovered during a renovation of the executive office building. The Moravian tile is of similar stock used in the capitol. Scrawled on the reverse is message, "We've realized it, Matthew, and you should also be proud! Merry X-Mas, 06."

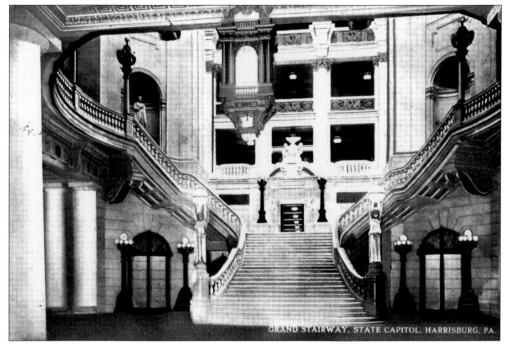

GRAND STAIRWAY, STATE CAPITOL, HARRISBURG, PA.

Twin alabaster angels hold globes of white light ushering visitors onto the dramatic grand staircase. Under the massive capitol dome, this escalade leads to Pennsylvania's legislative chambers. Architect Joseph Huston patterned this accomplishment after the one in the Paris Grand Opera House. Composed of Vermont and Italian marble, this symbolic meeting place has been lauded as the most beautiful on this continent.

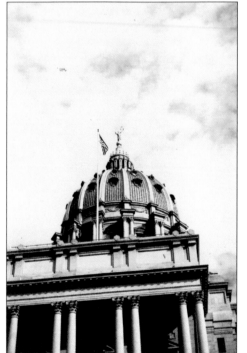

Modeled after St. Peter's Basilica in Rome, Harrisburg's most enduring point on the skyline rises 272 feet from the ground. Its many pilings sunk deep in the earth provide a stable base for this 52 million pound rotunda. Hard-fired green tiles are accented with a series of portals that allow natural light to bathe the interior. Poised on top is a 17-foot statue known as *Commonwealth*.

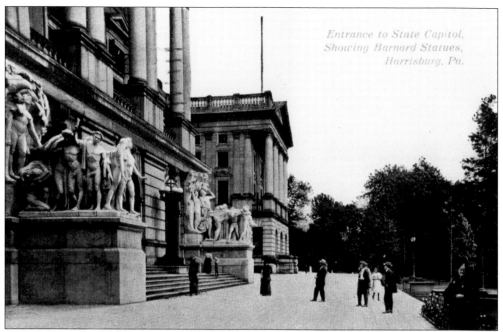

*Entrance to State Capitol,
Showing Barnard Statues,
Harrisburg, Pa.*

The original plans for the capitol called for additional embellishments to be placed as they became available. Commissioned in 1901, the George Grey Barnard statues flanking the entrance to the Pennsylvania Capitol Building were installed in 1911. Bernard was one of the most renowned sculptors of his day and these groupings were greeted with wide acclaim. A native New Yorker, it was Bernard's wish to be buried in Harrisburg, near his greatest work.

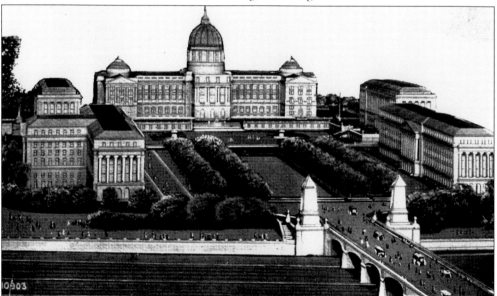

Shortly after the new capitol building was dedicated, planners on different levels of government began placing their focus on the surrounding grounds. A new capitol complex was envisioned. This required that the neighborhood behind the capitol would have to be eliminated. Joseph Huston left the rear of the capitol plain with the thought that expansion would eventually occur. This postcard circulated in the early 1920s foretold of these bold plans.

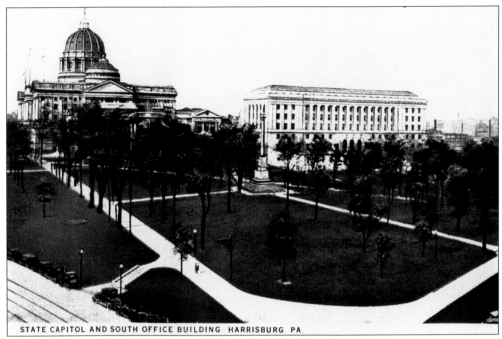

The capitol grounds around 1922 show the recently completed south office building. This was the first of a dozen major projects that would continue for years. The eighth ward neighborhood behind the capitol was almost a footnote in history. On Walnut Street, the greenhouses had been removed as were much of the old growth trees.

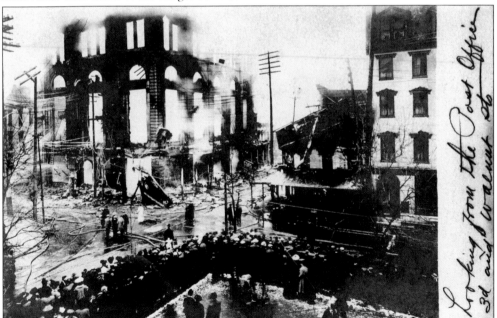

Viewed from the post office on Third Street at Walnut Street, the Grand Opera House lies in ruins on February 2, 1907. A slow-burning basement fire erupted and consumed a number of buildings burning out of control. This was Harrisburg's greatest fire with damages well over a million dollars. Ironically, 10 years earlier to the day, the old brick state house burned one block north.

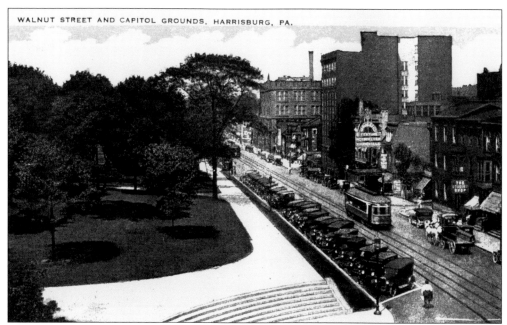

WALNUT STREET AND CAPITOL GROUNDS, HARRISBURG, PA.

A few years after the Harrisburg Opera House was razed, Walnut Street was experiencing a boom in automobile traffic. The city responded by painting designated lines for parking and implementing traffic rules. The Majestic picked up some of the smaller vaudeville acts that once played the Harrisburg Opera House. Walnut Street was slowly replacing some of the older buildings as a burgeoning legislature was bringing more business to this district.

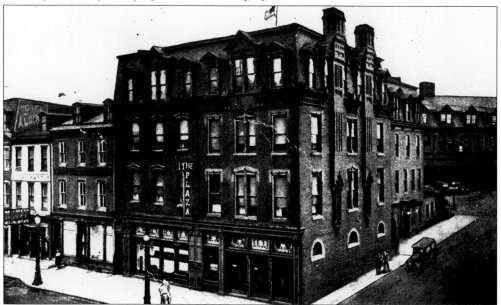

Small, 19th-century hotels were common in Harrisburg. More than a dozen were close to the capitol. Here at Walnut and Fourth Streets, the Aldine, the Martin, and the much-fancier Plaza found a place near the station. Each had a cafe. Many establishments would provide long-term lodging for elected officials while their jobs were in cessation. The Plaza had an extended menu and provided a very adequate evening meal.

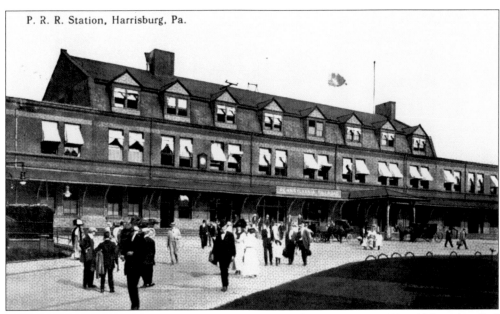

The Pennsylvania Railroad began construction on their latest station in 1887. Although called union station, the other rail companies continued to use their own depots in Harrisburg. Union station sat angled facing the business district at Fourth and Chestnut Streets. Over 100 trains a day thundered past this complex. The rails are located at a lower level through the train sheds in the rear.

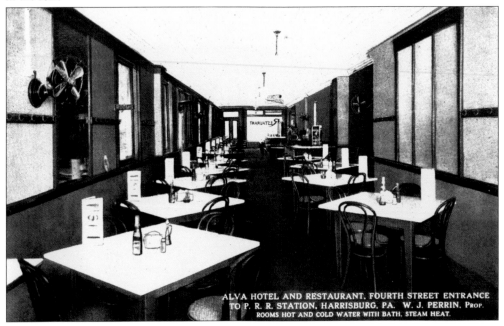

ALVA HOTEL AND RESTAURANT, FOURTH STREET ENTRANCE TO P. R. R. STATION, HARRISBURG, PA. W. J. PERRIN, Prop. ROOMS HOT AND COLD WATER WITH BATH. STEAM HEAT.

The Alva sits across the plaza where taxis wait for arriving travelers. Rail employees across the state have shared stories of the wonderful service and the top-notch meals eaten in the Alva Restaurant. This popular stopover celebrated its 100th birthday some years ago, and at the beginning of the 20th century, it was quite possibly the oldest restaurant using its original name in the city of Harrisburg.

The corner where the Grand Opera House had stood remained vacant for 10 years. The Citizens of Harrisburg opened a truly metropolitan hotel at Third and Walnut Streets in 1917. Eventually expanded to 400 rooms, the Penn Harris Hotel was often compared to the Waldorf Astoria in New York. Four unusual restaurants offered distinguished service. It was rated as one of the top hotels in east.

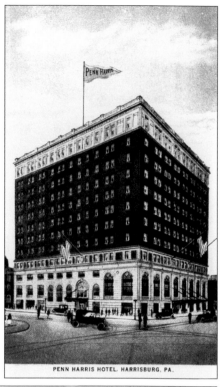

PENN HARRIS HOTEL, HARRISBURG, PA.

Walnut St. showing Penn Harris Hotel, Columbus Hotel and Post Office, Harrisburg, Pa.

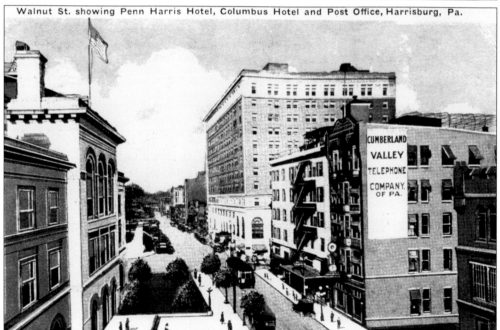

Around 1923, Walnut Street at Court Street is seen from the county jail on the right toward the Penn Harris Hotel. Cumberland Valley Telephone, an alternative to the Bell System, had offices here. Opposite can be seen the post office, which also had federal courtrooms. On the corner facing the Penn Harris Hotel is the rebuilt Columbus Hotel.

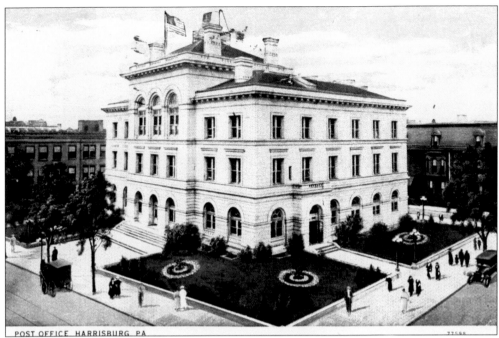

Construction of the post office building on Walnut and Third Streets began in 1882. It took 10 years to complete this building, which was a final part of what was called Federal Square. The rear portion was added later, doubling the size. Standing until the 1960s, the architecture complemented the capitol across the street. It was replaced with a glass-and-steel modern structure.

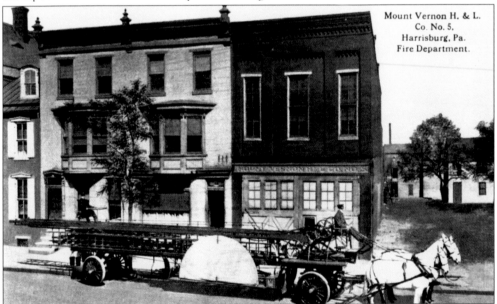

Mount Vernon H. & L.
Co. No. 5,
Harrisburg, Pa.
Fire Department.

Located at 519 North Fourth Street, the Mount Vernon Hook and Ladder Company was organized in 1858. For many years, this company housed the only ladder truck in the city. This American LaFrance truck arrived on the scene in 1909 and was drawn by three white horses. With the elimination of the eighth ward, Mount Vernon Hook and Ladder Company was dissolved into the Hope Company at 606 North Second Street in 1917.

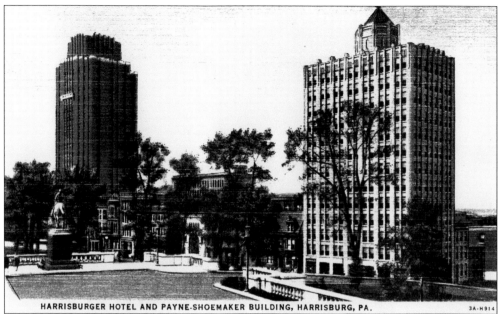

HARRISBURGER HOTEL AND PAYNE-SHOEMAKER BUILDING, HARRISBURG, PA. 3A-H914

The 1920s experienced a newfound prosperity in America. The country had rebounded from a war, and the economy had reached an unprecedented high. This era, sometimes called the jazz age, resulted in a frenzied period of development. In Harrisburg, the state legislature continued to expand. With each new policy or procedure introduced to the state assembly, a like number of lobbyists and attorneys were needed to balance the status quo. With land increasing in value, the alternative was to build upward to provide offices. Soon, facing the Capitol Park, there were wonderful art deco high-rise creations by celebrated local architects. Most notably was the paring of the sister buildings, the Harrisburger Hotel and the Payne Shoemaker building in 1930. This new generation of buildings on Third Street would eventually aid city planners when urban renewal took place later in the 20th century. These established towers became anchors in an updated cityscape.

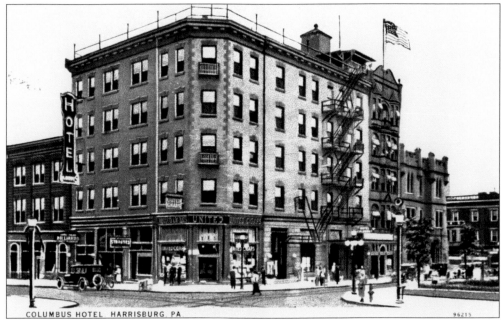

COLUMBUS HOTEL HARRISBURG PA 96215

The Columbus Hotel was repaired after the Harrisburg Opera House fire and continued operating on the corner of Walnut and Third Streets. United Cigars and a billiard parlor enticed legislators to frequent this spot during their recess. Dauphin County prison, built in 1841, sat to its rear at Court Street. The prison was torn down in 1957 after operations moved to Swatara Township.

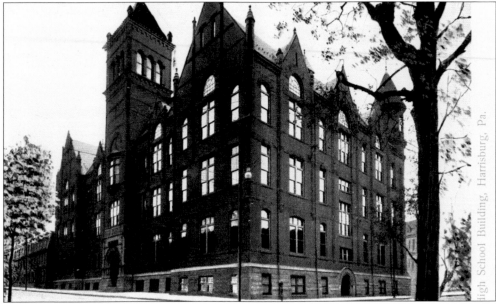

In 1891, the City of Harrisburg erected Central High School at the juncture of Forster and Capitol Streets. Traditionally many students left school by grade 9 to supplement family income. Pennsylvania's education requirements were changing and new curriculum was available for larger classes to continue through grade 12. This building served until 1959 when a final phase of the capitol expansion project consumed land to Forster Street.

Three

SUSQUEHANNA, THE RIVER BEAUTIFUL

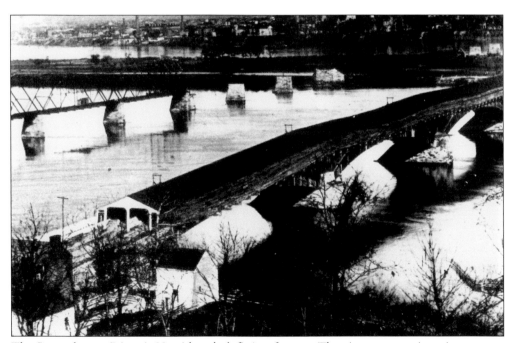

The Susquehanna River is Harrisburg's defining feature. The city can trace its existence to a simple ferry landing that brought pioneers beyond the established western frontier. But the sheer beauty of the river cannot be overlooked. Its steep banks and beautiful sunsets enjoyed from one of the country's original riverfront parks is a memorable event. Shown is the uncompleted people's bridge around 1890 with the unique Camelback Market Street Bridge.

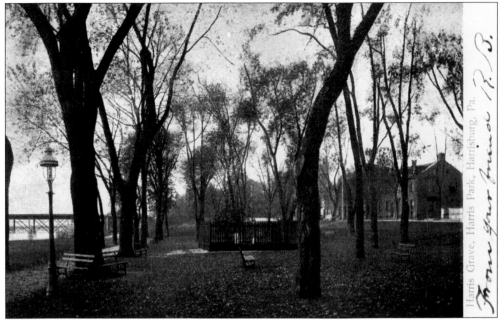

When John Harris Jr. began surveying the borough of Harrisburg in 1785, he had foresight to dedicate acreage along the Susquehanna River for boat landings. This preserved much of Harrisburg's waterfront. Four parks were later created on this tract. It was only fitting that Harris Park, across from the homestead, would be so named. This green ran from Paxton Street to Mulberry Street. John Harris Sr. chose to be buried on his riverfront.

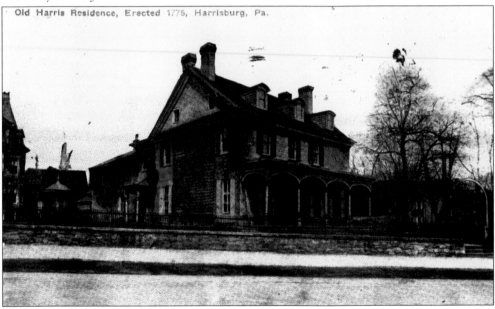

Old Harris Residence, Erected 1775, Harrisburg, Pa.

Founder John Harris Sr. died in 1748. His heir vacated the homestead often due to frequent flooding. In 1766, John Jr. built this house for his family high on the bank safely away from the fickle river. It was eventually owned and refurbished by Simon Cameron, who was a senator and Abraham Lincoln's secretary of war. Today this is home to the Dauphin Historical Society at 219 South Front Street.

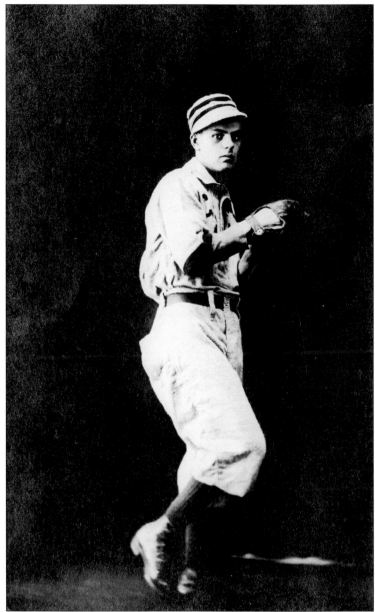

This left-handed pitcher represents the continuing spirit of Harrisburg baseball. It is quite possible that when this young man posed for photographer J. F. Fasnacht at 814 Market Street, he had hoped it might become a baseball card. From the 1880s when the Harrisburg Ponies won two championship games in the Middle States League to the excitement of the Harrisburg Senators reformation in the 1980s, City Island was the place to be. The municipal improvements on the island in the first decade of the 20th century led to the developments seen today. There was a time, however, when the island was void of sports. A downtime took place between the 1960s through the mid-1980s. City Island was one large municipal parking lot, and the filtration plant stood as a relic in a postindustrial age. Harrisburg's long-term mayor Steven Reed had a vision. Beginning in 1987, with his help, the island was transformed into a marvelous sports destination with a stadium and amenities to satisfy all ages.

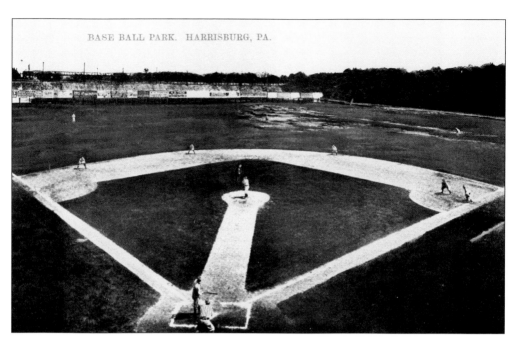

BASE BALL PARK. HARRISBURG, PA.

City Island, also referred to as Forster Island, has had an important presence in Harrisburg's history from the time that the original Market Street Bridge used it as an anchorage. This 63-acre island in the middle of the Susquehanna River was originally used for farming. Baseball appeared on City Island in the 1880s. Various teams played in different leagues over the next two decades.

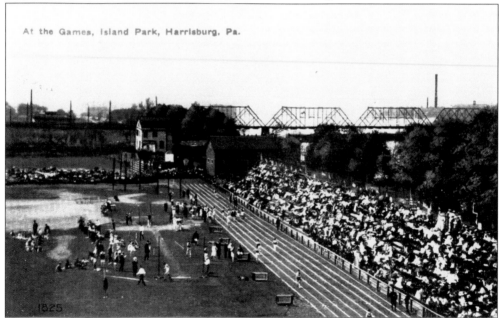

The roar of the crowd could be heard all over Harrisburg. Notables such as Satchel Paige, Babe Ruth, and Jim Thorpe played ball here. Not only baseball was played on the island. The police demonstrated their horses, ice hockey was a popular event, and many other sports activities used the south end. A filtration and pumping station supplied Harrisburg with water on the north side of the island. Boats also wintered here.

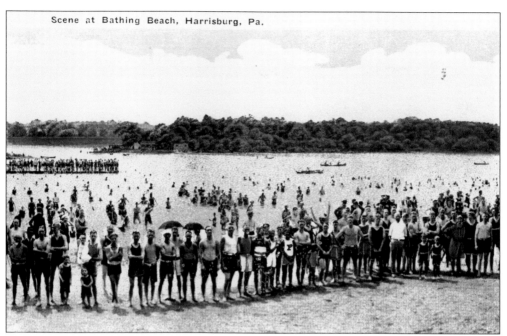

Scene at Bathing Beach, Harrisburg, Pa.

Since the industry in the early years was located along the Paxton Creek, the Susquehanna River escaped most of the factory pollution that plagued other cities. However, sewage did drain directly into the river. Part of the Front Street park development included an intensive effort to rectify this problem. Eventually the river was clean enough to be enjoyed by bathers. For a few generations, City Island had very busy beaches.

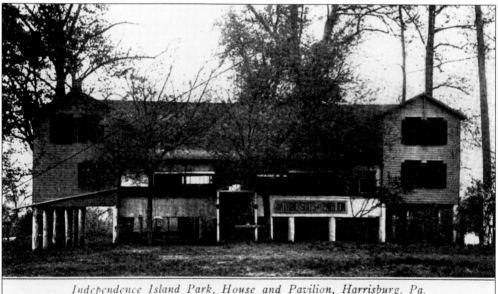

Independence Island Park, House and Pavilion, Harrisburg, Pa.

At the beginning of the 20th century, the river above Verebeke Street was beyond the pollution. The city had previously established a recreational haven on Independence Island. A few hundred could be accommodated at this combination bathhouse picnic pavilion in the heat of the summer. A bathing beach that resembled an old swimming hole drew residents from all over the city. Some came just to enjoy a walk along the pathways.

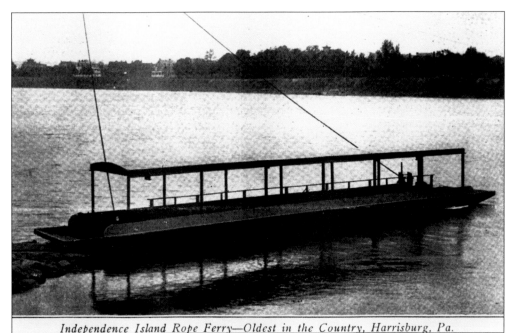

Independence Island Rope Ferry—Oldest in the Country, Harrisburg, Pa.

Independence Island had no bridge and one could not wade the distance. On the banks of the Susquehanna River was a curiosity. A rope ferry provided the only access to the island. A rope was strung above from shore to shore. Looped to this a long flat boat fastened on both ends. With only the power of the moving current against a rudder, the boat could swiftly make a crossing.

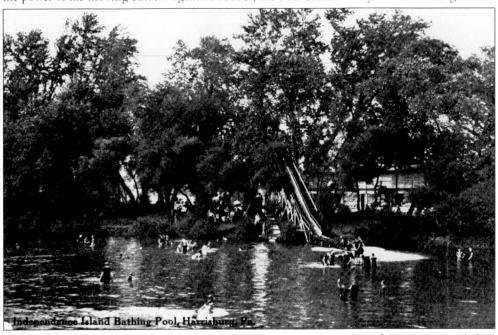

Independence Island Bathing Pool, Harrisburg, Pa.

The island provided a refreshing spot for the children. When the dirt of the streets was baked in the sun and the air was short of a breeze, the bathing pool situated among the trees on the narrow island made a child forget all cares. Being able to splash and frolic in the water without having to carry buckets from a city fountain was a true luxury for some.

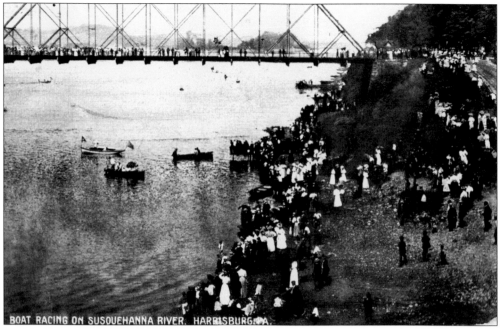

Harrisburg's fascination with the Susquehanna is evident in its most enduring event. Kipona, a Delaware Native American word meaning "sparkling waters," is the name given to an annual celebration on Harrisburg's waterfront. Traditionally it involved boating competitions. This early view shows the organization of a race on the water. Paving was an idea of the future, and the eroded banks did not stop a throng from getting a closer look.

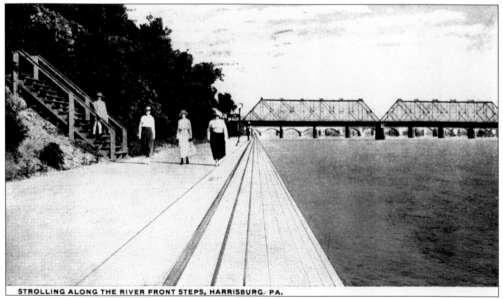

A bold development in the City Beautiful Movement of the first quarter of the 20th century was construction of the front street steps. A paved walkway was built above normal water level. Concrete steps led from this to a paved walkway above. A bank with intermittent steps reached the new Front Street concrete pathway. This arrangement achieved an embankment that did not erode with the fluctuation of the river level.

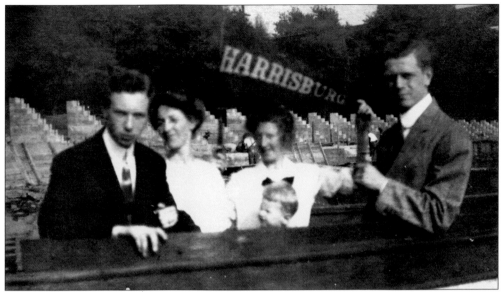

On an outing on the Susquehanna River, two couples enjoy a leisurely ride on the riverfront. What is unusual about this photograph is the timely glimpse of the actual construction of the concrete steps taking place in the background. When complete, this marvel would traverse five miles of waterfront. They are identified as the Baxter family. Sources indicate the steps were begun in 1912. The Harrisburg banner is a fitting touch.

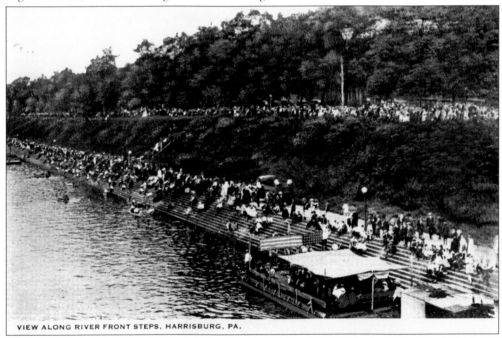

VIEW ALONG RIVER FRONT STEPS, HARRISBURG, PA.

Kipona takes on a completely different feel with the riverfront steps in place. There is more order and space to assemble a crowd. Each year the celebration grew with additional events added to the venue. Eventually live music and an art show would become an integral part of Kipona, in addition to a wide variety of food vendors. Dusk would welcome a spectacular show of fireworks.

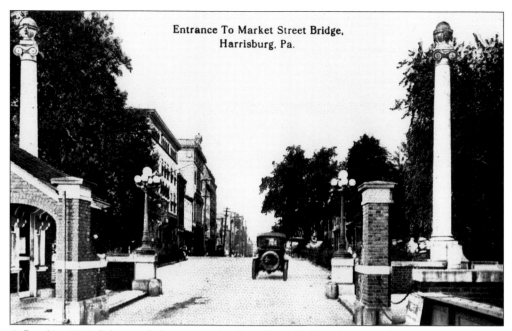

Entrance To Market Street Bridge,
Harrisburg, Pa.

A flood in 1902 did enough damage to the Camelback Bridge that its replacement was ordered. The new Market Street Bridge opened in 1905. It was immediately a popular place to visit. The entrance to the bridge at Front and Market Streets was laid out with a circular plaza with benches and walkways. It is unfortunate that automobile traffic would make this bridge obsolete in one generation.

Harrisburg, Pa. Entrance to Harrisburg Bridge.

Toward the end of the day, a wagon is returning to the west shore after leaving the market. Looking west from Front Street toward City Island, the entrance is flanked by two columns. These were salvaged from the old capitol building that burned in 1897. On the right is the toll house. Beyond that is the Peoples Bridge. Market Street Bridge had always collected tolls and would continue until 1957.

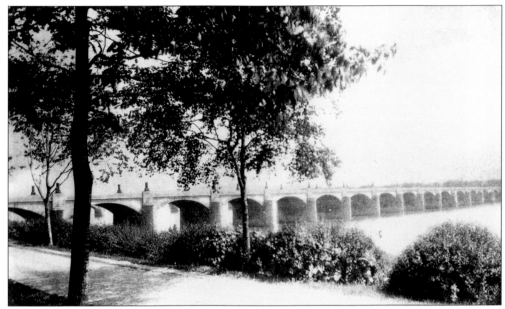

In 1906, 11,000 motorcars were registered in Pennsylvania. That is the first year registrations were recorded. In 1924, the number fitted with plates exceeded one million for the first time. Increased traffic now effected how bridges would be designed. In 1926, Market Street had a major rebuilding. Doubled in width, it was redesigned in a modern style that ranked it as one of the finest in Pennsylvania.

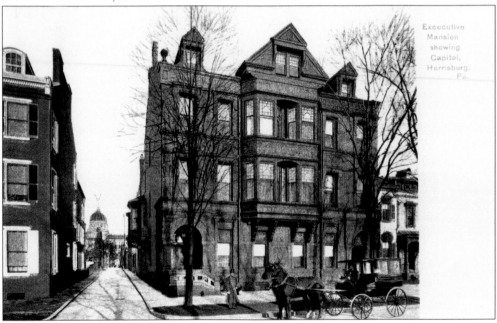

Keystone Hall, on Front and Barbara Streets, served as the executive mansion for 26 governors between 1864 and 1960. Originally a single home, a twin was later added. Subsequently the frontage was encapsulated in Queen Ann brownstone in the 1880s. This image is penciled "Gov. James Tenent" on the reverse. That may be him in the greatcoat. Irish born, he was a professional baseball player before he was inaugurated governor in 1911.

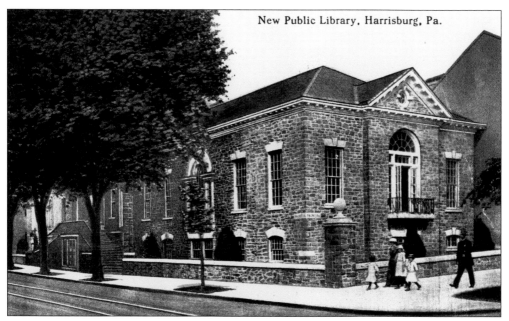

New Public Library, Harrisburg, Pa.

Harrisburg had a public library since 1889, but this was its first permanent home. The Haldeman family lived for many years in a mansion at 27 North Front Street built in 1810. Their side yard became the Harrisburg Public Library when James McCormick Jr., an architect neighbor, erected this tidy Georgian Revival limestone structure in 1914 at 125 Locust Street. It has since become a Front Street landmark.

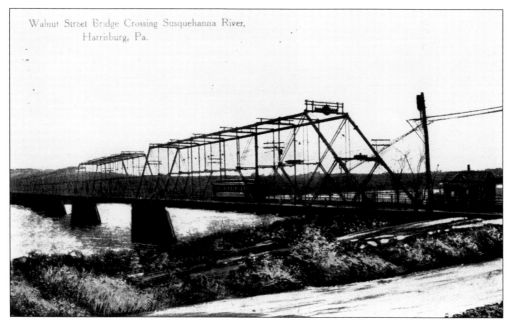

Walnut Street Bridge Crossing Susquehanna River, Harrisburg, Pa.

The Peoples Bridge was built by Elizas A. Wallower at Walnut Street as a protest against the monopoly of river crossing controlled by the Market Street bridge company. Opened in 1890, it competed to keep crossing tolls affordable. It became a major link to the Cumberland Valley as a viaduct for street rails. Note that park improvements had not begun at this juncture.

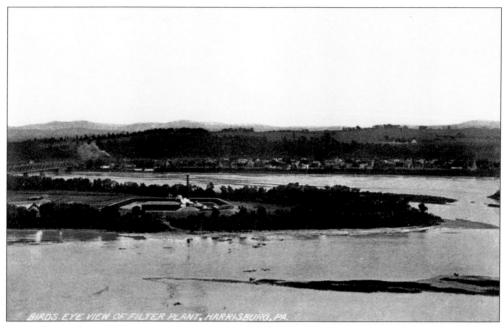

From the stand pipe on Front Street, City Island is viewed. The filtration plant is at center on the north end of City Island. Wormleysburg is in the distance. On the hill, union forces from New York State stood guard over Market Street Bridge in 1863 as Confederate forces approached. The area is still referred to as Fort Washington.

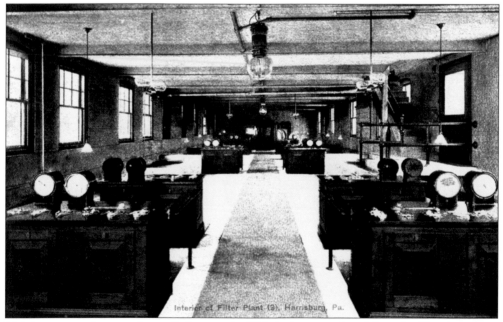

This is not a set from a science fiction movie. This is the operations lab at the filtration plant. Water, pulled from the river, was processed and transferred through a large submerged pipe to Front Street and then relayed to the reservoir on Allison Hill. The 1936 flood made it apparent that a mountain-fed reservoir was necessary. Ice flows clogged Harrisburg's water supply for more than a week, causing rationing.

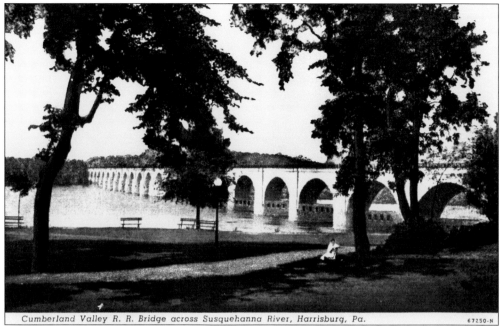

Cumberland Valley R. R. Bridge across Susquehanna River, Harrisburg, Pa. 67250-N

The Cumberland Valley Railroad replaced a cast-iron 1870s trestle with this high-arched concrete bridge in 1916. One of the nation's oldest rail concerns, the Cumberland Valley Railroad was chartered in 1831. This is the fifth bridge to cross at this point. When the design was unveiled, it was hailed as a stupendous complement to the improvements taking place on the Susquehanna River at Harrisburg. It has become an icon on Harrisburg's waterfront.

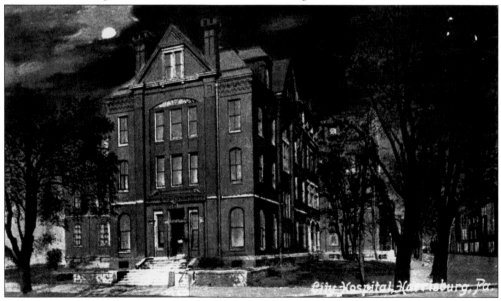

Harrisburg's first public hospital opened in a school on Mulberry Street in 1873. It was later joined by this building that faced Front Street and was dedicated February 22, 1884. With the Cumberland Valley Railroad tracks conveniently passing by, many patients arrived carried in a special locomotive pulling a caboose that acted as an ambulance. A Civil War–era army ambulance pulled by horses was on hand to fetch others.

45

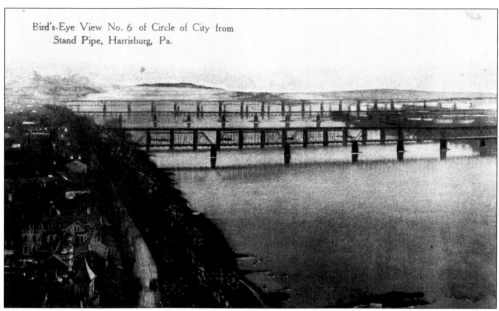

In 1903, a photographer took a proof for this postcard from atop the standpipe at North and Front Streets looking south. He caught an interesting image. Market Street Bridge is missing. The footers of the old Camelback Bridge have been cleared for new construction. All bridges in sight are all of iron. It would be a number of years that the stone and concrete bridges would appear.

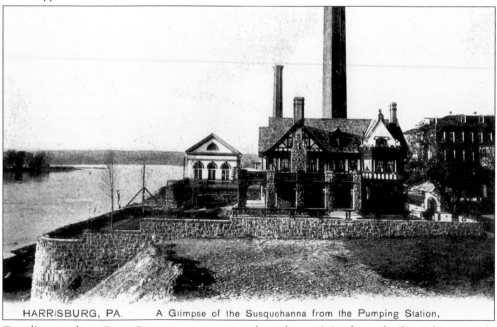

HARRISBURG, PA. A Glimpse of the Susquehanna from the Pumping Station,

Traveling north on Front Street one encounters the only surviving house built on the west side of the drive. The Flemming family contributed much to Harrisburg. Their enduring legacy is the home they built next to the neoclassical pumping station at North Street. They fortified it with a natural stone wall prior to the city taking the initiative to combat erosion. The Flemmings enjoyed an unparalleled view of the Susquehanna River.

The waterworks was updated in 1902 at a cost of $2 million. Pumping water from the Susquehanna River, it had a capacity of 10 million gallons daily. Some 15 tons of coal a day was burned to power this plant providing the average of 60 gallons per household for domestic purposes. This was all forwarded to a new reservoir in the hill district. From the profits, $30,000 was spent to develop Reservoir Park.

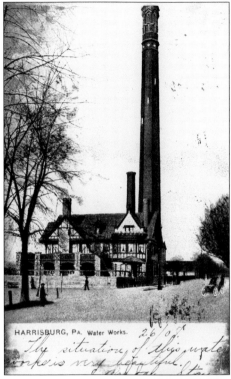

HARRISBURG, PA. Water Works.

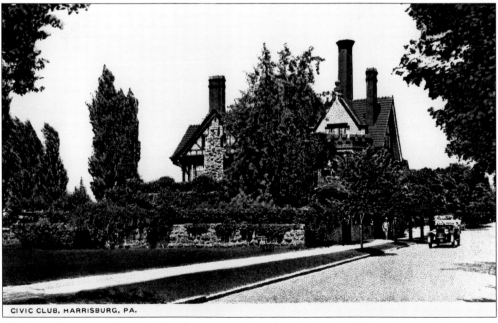

CIVIC CLUB, HARRISBURG, PA.

Virginia Flemming died in 1914 having survived her husband William Reynolds Fleming. She left "Overlook," built in 1901, to her pet charity, the Civic Club. It is now a Harrisburg institution. A ballroom was erected above the first floor porch for receptions and recitals. Great improvements in Harrisburg's appearance found their genesis within these walls. The home's authentic interior and outdoor gardens make it a truly enriching riverfront experience.

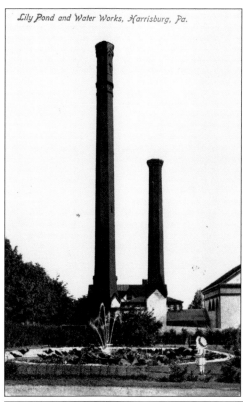

Lily Pond and Water Works, Harrisburg, Pa.

The standpipe at the water works was an architectural curiosity in Harrisburg. It was also the tallest structure for miles, upon completion in 1876. Water pumped into this vertical storage facility created pressure from its own weight. When released, a strong flow resulted that pushed water through many miles of pipes to a distant reservoir. An added benefit is the manicured grounds that surround these water-processing facilities.

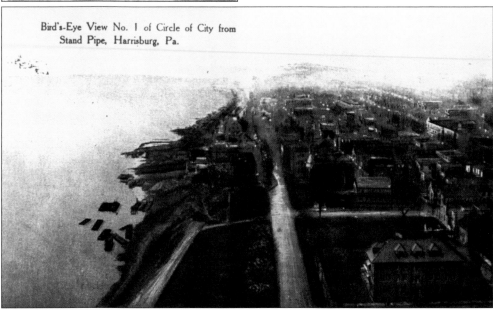

Bird's-Eye View No. 1 of Circle of City from Stand Pipe, Harrisburg, Pa.

The standpipe provided the best vantage point for photographing the city below. A service stairway provided a climb to the top of this structure. Seen looking north near the old silk mill is the part of Harrisburg dubbed the "Hardscrabble" district. Buildings west of Front Street on the water would be razed for civic improvement. Dintaman's boatyard with its rafts can be seen near Forster Street.

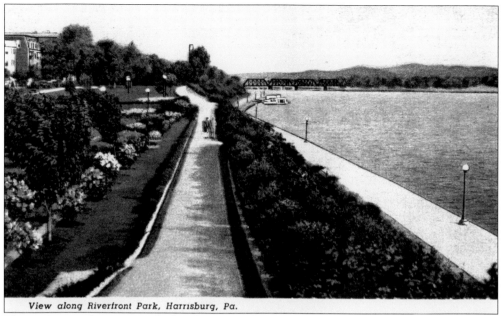

View along Riverfront Park, Harrisburg, Pa.

The sunken gardens appeared after the homes that existed on the water front from Herr Street northward at Hardscrabble were removed. The City Beautiful Movement saw the parks northward improvement keeping pace with the city's growth. Front Street landowners donated their frontage for the assemblage of the park as part of their civic duty. Ironically, the steps installed below actually concealed components of an advanced sewage treatment system.

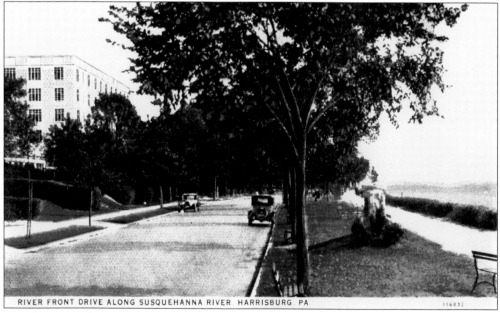

RIVER FRONT DRIVE ALONG SUSQUEHANNA RIVER HARRISBURG, PA

Another contributing factor to Front Street Park improvement was the increasing use of automobiles. What had been similar to a country road at some points now required grading, widening, and paving. New trees were planted to shade this beautiful promenade. During the 1920s, many large homes and distinctive apartment buildings began appearing on the east side of the drive traveling northward.

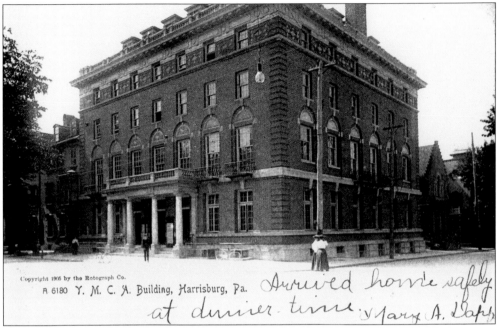

A 6180 Y. M. C. A. Building, Harrisburg, Pa. *Arrived home safely at dinner time. Mary A. Dapp*

The YMCA movement was established before the Civil War. Its principles were to provide a place for young men to study and socialize away from pubs, gambling, and other vices. Harrisburg's first affiliation with the YMCA was in 1854. After a number of temporary quarters, funds became available to build a YMCA on Second Street at Locust in 1902. Here the fitness program was the best in the city.

Building a sound mind with a strong body became a motto of the YMCA. When their popularity caused them to outgrow the building on Second Street, the old cotton mill on North and Front Streets became available. This provided an enormous building lot. Soon construction began on a Romanesque Revival building that would stand out as one of Harrisburg's most unique facilities in 1932.

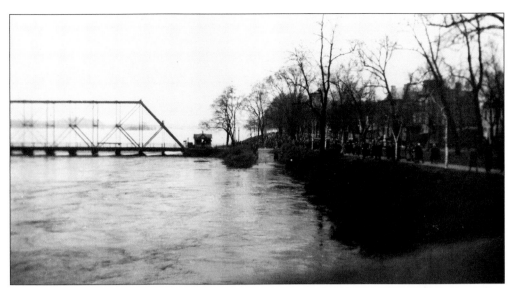

People lined the banks at the Peoples Bridge while the whole city and the West Shore communities became deluged on March 17, 1936. Harrisburg was very familiar with floods, but this one rocked the state as no disaster had. The Peoples Bridge stood strong, though. After this disaster, Congress finally addressed legislation that brought flood control a responsibility of the federal government.

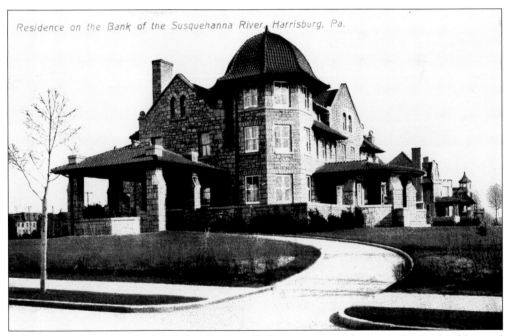

With the advent of the automobiles along with the expansion of street railways, land beyond Division Street became the desirable place to live. Many large homes facing the river were built on Front Street. From Colonial Revival to Spanish Revival, all styles were represented. Some had grounds covering a city block. Later when they became unfashionable as homes, they found new lives as corporate offices or places of business.

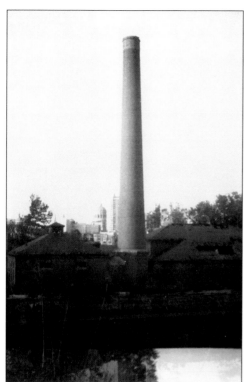

This unusual view is taken from the rim of the holding pond on City Island facing the filtration plant and power house buildings. The capitol dome can be seen in the background. This facility stood many years as a vestige of a long ago industry. In 1987, a stadium and a concessions park brought new life to the middle of the Susquehanna River on this very spot.

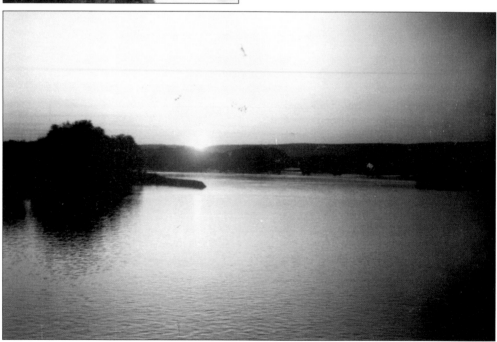

Anyone who has strolled River Front Park or has crossed the M. Harvey Taylor Bridge in the evening can tell of the beautiful sunsets that are enjoyed on the Susquehanna River. Set against a backdrop of the hills of Perry County northwest of the city, it reflects dramatically on the wide and shallow Susquehanna River. This view is unspoiled and appears as it has for a generations.

Four

BUSINESS AS USUAL

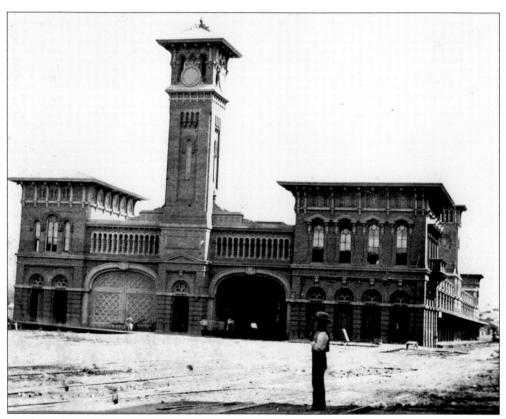

Final touches are applied to Harrisburg's new Italianate-style station in 1857. On August 1 of that year, the first train rolled through. On the same day, the Pennsylvania Railroad took possession of the main line of the state's public works, begun in 1846 as the Pennsylvania Central Railroad. Over the next century, the Pennsylvania Railroad would operate as the major force the in economy of Harrisburg.

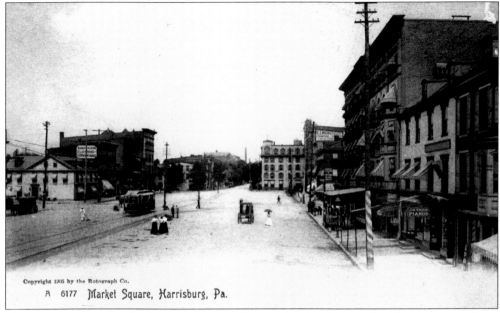

A 6177 Market Square, Harrisburg, Pa.

The street sweeper was finishing up on an early morning in 1904 as a few shoppers went about their business. The square was void of market stalls. The last one was pulled down in 1889. However, a few hucksters continued to set up on the sidewalk. A number of Federal-era buildings still faced the square, however their days were numbered. Note the barber stripes painted on the telephone pole.

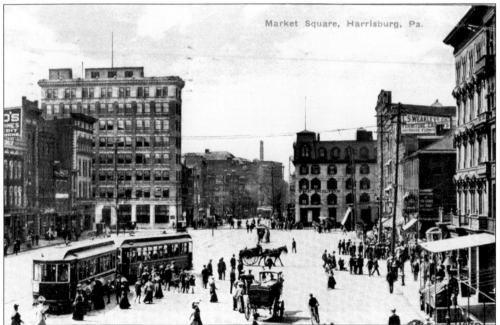

Market Square, Harrisburg, Pa.

A busy day at about noon in 1907, Market Square bustles with people. Every conveyance imaginable can be seen, except an automobile. The cityscape is changing. This is a far cry from the square that was laid out when the city was planned. In the 1790s, the first vendors set up on this spot. Then it was an open field that many times took on the look of a swamp.

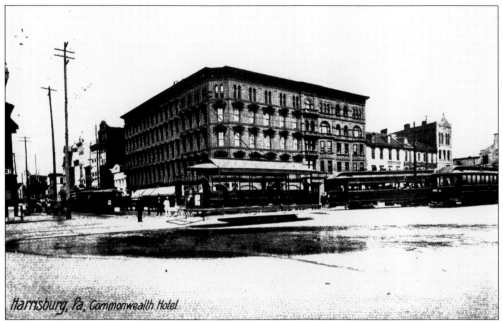

Harrisburg, Pa. Commonwealth Hotel

On the Southeast corner of the square, sits the Commonwealth Hotel. Once the Jones House, it was here that Abraham Lincoln stayed on his way to his 1861 inauguration. Thousands came to see the parade. This event roused the Union supporters to nearly unprecedented levels of patriotism. In front of this hotel, the street cars for the entire region find their terminus. The single vehicle at center is a summer trolley.

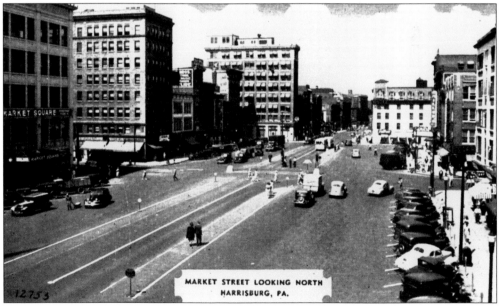

MARKET STREET LOOKING NORTH
HARRISBURG, PA.

By 1938, the old market had taken on a new face. Most of the buildings of the previous century were memories. Department stores, theaters, and the automobile were the current theme. The 1936 flood undermined most of the regional rails. Busses now stopped on the island in the center of the square. The automobile boosted the number of visitors to the city and gave the city a more cosmopolitan feel.

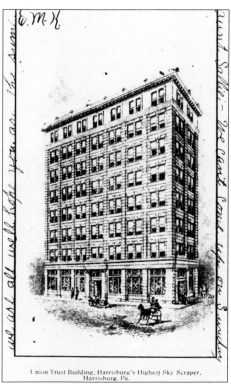

Union Trust Building, Harrisburg's Highest Sky Scraper,
Harrisburg, Pa.

The Union Trust Building was erected on the northeast corner of Market Square in 1906. This marked the growth of Harrisburg as a major financial center. Harrisburg's first skyscraper exemplified the beginning of a growth upward in the city. Built by the same firm that built the capitol, George Payne and Company, this was one of a number of projects spawned by the completion of the new seat of government.

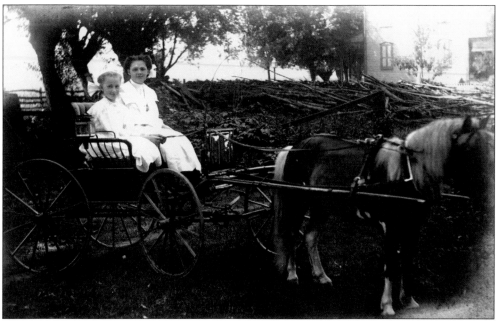

After 1905, photographers added a new product to their services. The personal-use postcard was a photograph with the reverse side designed for the address and a message. It followed strict postal guidelines. Photographers were kept busy visiting homes and businesses. John F. Fasnacht was called on to take a photograph of two sisters. On the reverse Polly tells her grandmother of a visit to Chestnut Street Market in Harrisburg with her sister.

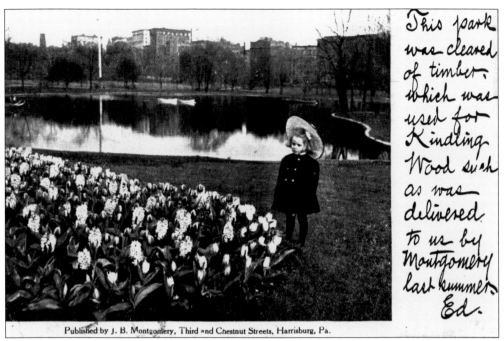

This park was cleared of timber. which was used for Kindling Wood such as was delivered to us by Montgomery last summer. Ed.

Published by J. B. Montgomery, Third and Chestnut Streets, Harrisburg, Pa.

In 1905, kindling was a hot commodity. Stored in the scuttle by the kitchen range for lighting coal, these bundles of switches were a necessity. J. B. Montgomery Company, at Third and Chestnut Streets used it to their advantage to publish a series of advertisement cards as the city cleared acres of neglected land for public use during the City Beautiful Movement. Montgomery was conveniently contracted to remove the debris.

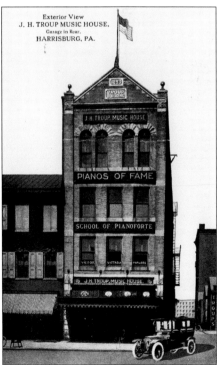

The Troup family provided the region with music for generations. They built this house of music at 15 South Market Street. There were showrooms filled with pianos in home-like settings. The Troups had talented musicians on hand to demonstrate various instruments. If one stopped by in the 1930s, a young Bobby Troup may have been there to provide assistance. He composed "Route 66" among many other hits and appeared regularly on national television.

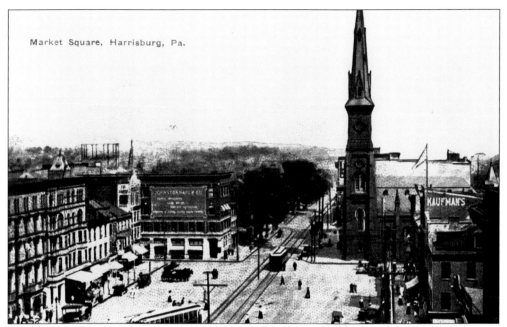

Market Square, Harrisburg, Pa.

Since 1859, the Presbyterian Church at the south end of Market Square has added a tremendous profile to Harrisburg. Its 193-foot spire is the highest in the city. This was the most prominent feature of any 19th-century print. It also separates Market Square from the older neighborhoods to the south. At upper left of this image is the gas plant, which provided lighting to the city before electricity.

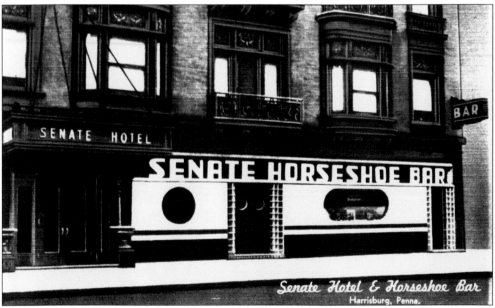

In the 1920s art deco architecture and ornamentation became a popular mode of style and evolved over the next two decades. A number of art deco hotels and office buildings were built in Harrisburg during this period. Some older buildings were simply updated with the glass, chrome, and stylized lettering. The Horseshoe Bar at the Senate Hotel on Market Street is a fine example of this movement.

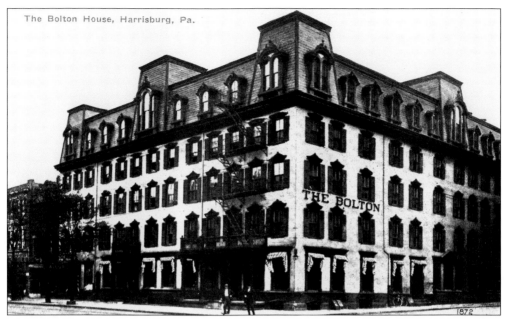

The Bolton House, Harrisburg, Pa.

In 1812, a three-story hotel opened on Second Street. The Eagle became Harrisburg's premier hotel, serving the city from the time the state legislature arrived. Charles Dickens stayed here in 1842 and mentioned the Eagle in his book *American Notes*. In the 1860s, a series of neighboring townhouses were added to the Eagle with additional floors. A common roof Victorianized this grand hotel, which was renamed the Bolton. It stood until 1990.

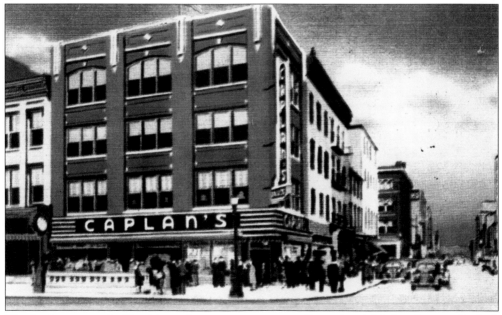

The busiest corner in Harrisburg for many years was at Second and Market Streets. Caplan's Pharmacy, with its lunch counter and soda fountain, was a popular meeting place for teens. During wartime, servicemen mobbed the square and usually found seating here. Sam "The Bookman" Levin manned a newsstand in front of Caplan's beginning in 1929. The reverse of this card reads, "Stop by Caplan's! Your photos are ready."

59

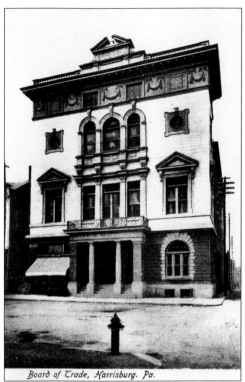

Board of Trade, Harrisburg. Pa.

As Harrisburg evolved into a major industrial, commercial, and financial center, it became apparent that an organized base of operations was necessary for promoting and improving the city. The Board of Trade building was erected at 112–116 Market Street in the 1890s. The Harrisburg League of Civic improvement operated here. They were the impetus behind the City Beautiful Movement. The Board of Trade eventually became the Chamber of Commerce.

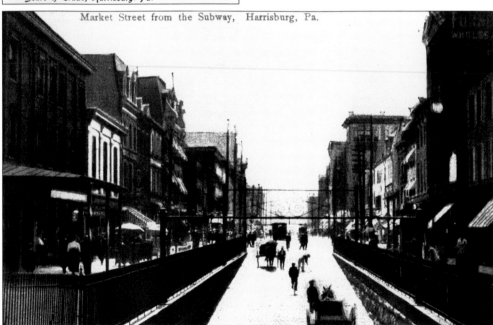

Market Street from the Subway, Harrisburg, Pa.

When the first rail lines were laid in the 1830s, no concerns were raised about street crossings and the safety of pedestrians. Many streets crossed directly through the yards. The speed, frequency, and number of trains escalated drastically over the years. Consequently the danger of rails became an issue. Tunneling was the compromise. Market Street had a subway installed in 1902 in the 500 block. Other streets soon followed.

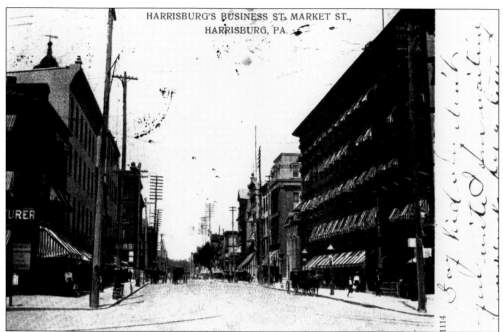

This late-1890s image of Market Street is prior to the age of the automobile. The Commonwealth Hotel is decked out with awnings. Cigars are popular. The first building on the left manufacturers and sells them. Further down the street is another cigar store. The Commonwealth Hotel has installed gas street lamps. A pair matching these is also around the corner on Market Square.

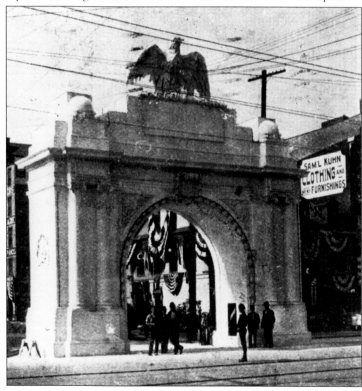

In October 1905, Dauphin County celebrated Old Home Week. Miles of bunting were draped over businesses and homes in center city. Some 25,000 visitors returning to their home city were treated to the thrill of electric lights strung through town and parade floats highlighting products of local industries. Attendees saw the developments taking place in Harrisburg's progressive improvement. The triumphal arch placed on Market Square was the official entrance to the festivities.

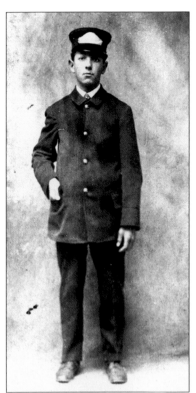

A young Howard Sites lived in an apartment at 411 Market Street in 1903. As was customary at the time, he was photographed in his full uniform. Employed as a conductor on a streetcar, he actually passed his home many times a day on the Market Street loop.

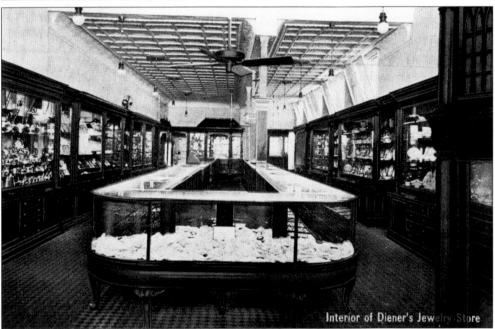

Interior of Diener's Jewelry Store

In 1915, a young lady looking for a fine set of china or perhaps wanting to try on a ring would stop at P. G. Diener's Jewelry Store at 408 Market Street. Everything was stored in mahogany cases with plenty of sales associates to lend assistance. This was one of a handful of fine jewelry stores in the city. Records indicate that P. G. Diener's occupied this location for many years.

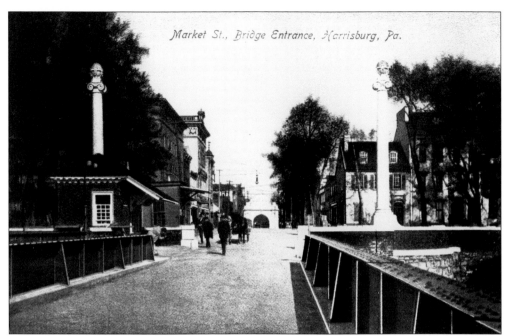

The new Market Street Bridge is shown in autumn of 1905. The temporary triumphal arch is in the distance. Curiously caught at this moment, the toll taker gestures a gentlemen toward the new booth. The houses on the right would be razed for a new county courthouse in 1941. The Kelker Mansion at 9 South Front Street would be one of these. It was once home to the Dauphin County Historical Society.

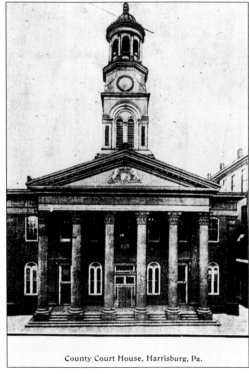

This image of the Dauphin County courthouse was taken about 1905 at Market and Court Streets. This neoclassical structure was built in 1860, replacing an earlier 1792 courthouse. In the 1940s, a new facility was built on Front and Market Streets leading to this one's demolition. The rear exit of this court house faced the back of the Walnut Street prison across Strawberry Alley.

County Court House, Harrisburg, Pa.

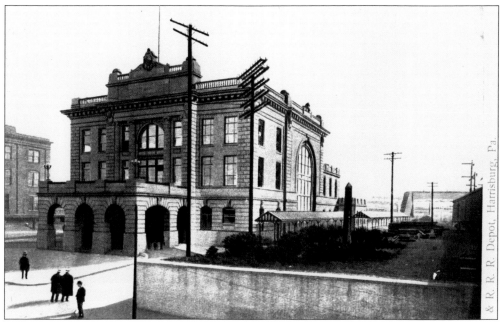

The Reading Railroad was a presence in Harrisburg for over 125 years. Their fifth and final station was located on Market Street in the 800 block. Until this building was completed in 1904, they continued business across the street. About 22 passenger trains used this station daily, in addition to a nearby busy freight station. Reading Station passed into history in the early 1960s with the arrival of the new postal center.

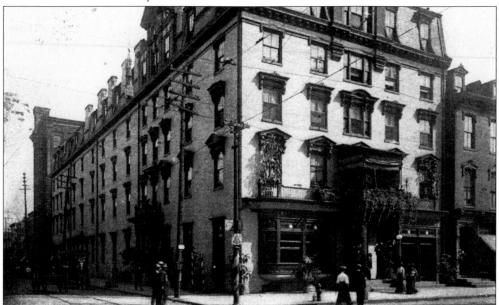

This 1903 view is the Lochiel Hotel on Third and Market Streets. Built in 1835 in the Greek Revival style, it was originally called the Wilson. Many notables stayed here, including Daniel Webster and the world's songbird, Jenny Lind. In 1839, Harrisburg hosted the Whig Presidential convention at nearby Zion Lutheran Church nominating William Henry Harrison and John Tyler as president and vice president. The Wilson became campaign central.

The name Lochiel Hotel was given when the Wilson was restyled in the late Victorian era. With a name change to the Colonial, it became a stage theater in 1912, booking performers of the vaudeville circuit. Harrisburg now had a suitable showplace since the passing of the Grand Opera House. The Colonial doubled as a movie house continuing into the 1970s. It was sensitively restored in the 1980s, surviving urban renewal.

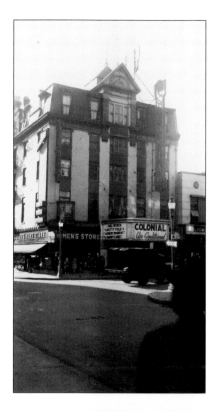

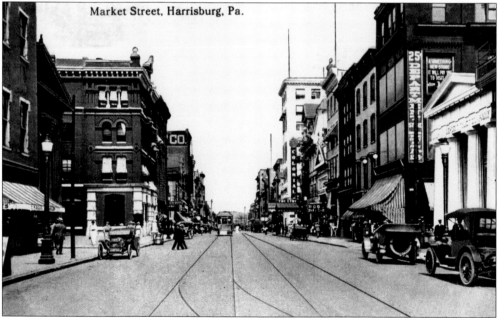

In 1915, the automobile was gradually becoming a more familiar sight on the streets of the city. Here one can see Market Street looking east from Court Street. Dauphin Deposit Bank is on the right. Each year seems to bring more businesses. The 25¢ Department Store appears next to the bank. It would eventually be replaced by G. C. Murphy. Discounts stores were gaining popularity.

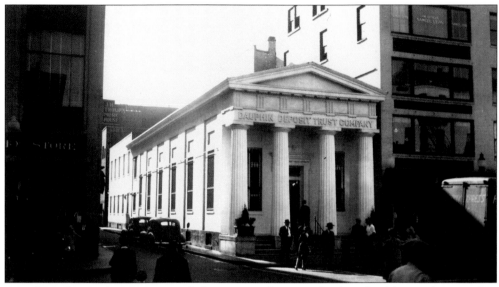

On a busy day in the 1940s, people have come down to do their banking at the Dauphin Deposit Bank. Built in 1839 at 213 Market Street, this form of Greek Revival architecture is a true example of a traditional banking institution and exists to this day. Dauphin Bank played a strategic part in this city's emergence as a major commercial center.

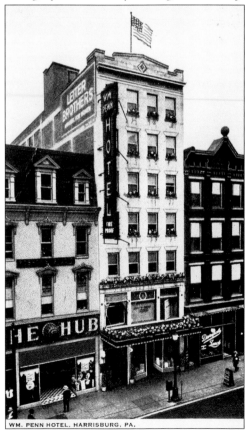

The 150-room William Penn Hotel in the middle of the 300 block of Market Street on the south side was one of the new fireproof buildings being then constructed in 1922. With reinforced concrete floors and an all-steel frame, combustible materials were omitted from the plans. If a room burned, it was contained. Davenports, on the right, became a national food service chain under different names.

Shenk and Tittle was located at 313 Market Street. There was always something in the window to hold one's attention. The whole block added to a dynamic shopping district. Kinney Shoes at 319 Market Street was a large area employer. In addition to a large retail outlet on Market Street, they employed thousands over the years at their plant on the West Shore. Before shopping malls, downtown Harrisburg provided everything.

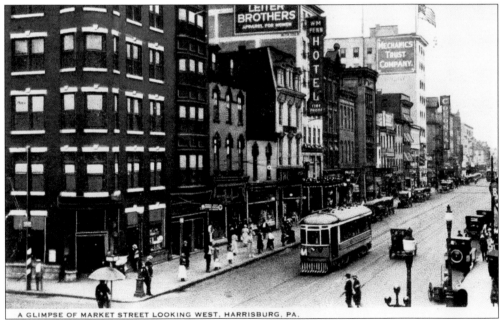

A GLIMPSE OF MARKET STREET LOOKING WEST, HARRISBURG, PA.

On a busy day in 1924, a streetcar approaches Fourth Street on Market Street. The building on the extreme left is the Governor Hotel. Built in 1908 as the Metropolitan, it has been incorporated into the structure of the colossal 333 Market Street building built the 1970s. All other buildings shown up to the Mechanics Trust Company are now memories. The traffic cop has signs that read "Stop!" and "Go!"

The north side of Market at Third Street has busses lined up to transport shoppers. There is no shortage of signage in this busy town. Even Mr. Peanut has his place. The Penn Harris Hotel can be seen on Walnut Street. When it was removed in the 1970s, much of what is seen became part of the phase one of Strawberry Square, an urban shopping mall.

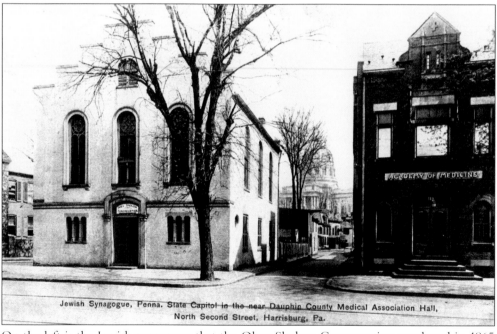

Jewish Synagogue, Penna. State Capitol in the near Dauphin County Medical Association Hall, North Second Street, Harrisburg, Pa.

On the left is the Jewish synagogue that the Ohev Sholom Congregation purchased in 1865 from the Methodists. Formed in 1853, they were Harrisburg's first temple. This reformist group outgrew this 1820 building and built a larger temple at 2345 North Front Street. On the right is Dauphin Academy of Medicine at 319 North Second Street at South Street. Many of Harrisburg's prominent physicians listed this school on their resume.

Opened as Dives', Pomeroy and Stewart at the opera house building in 1878, Pomeroy's Department Store at Fourth and Market Streets became the largest in central Pennsylvania. This mailer was sent just before Christmas. The gleeful young lad with his favorite toy said it all. On the reverse, the simple words "The day approaches when the world awakens to magic! Our toy department is fully stocked and awaits you!"

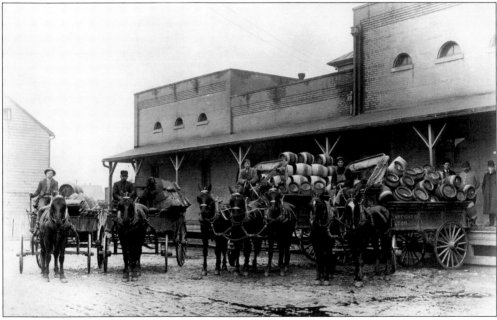

Harrisburg has been home to several breweries over the years. The two with the most output were the Robert Graupner Brewing Company and the Fink Brewing Company. Just south of Harrisburg is the borough of Steelton, incorporated in 1880. Steelton grew up around Pennsylvania Steel Company, the first plant that produced steel exclusively. Their brewery was the National Brewing Company. Here the proud brewers display their finished product before delivery.

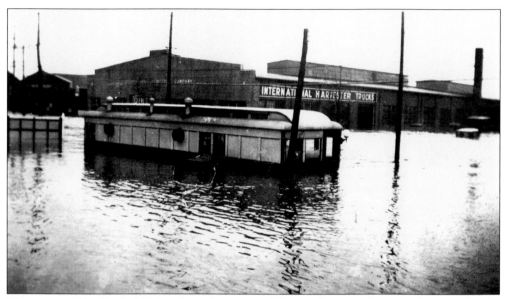

The owner of the Capitol Grille chose the corner of Paxton Street at Cameron Street as the site for his diner. Here he was guaranteed the heaviest traffic in the city and a constant stream of hungry workers. It is also an unfortunate spot during a flood. Both the Susquehanna River and the Paxton Creek made a lake of this neighborhood during the great flood of 1936.

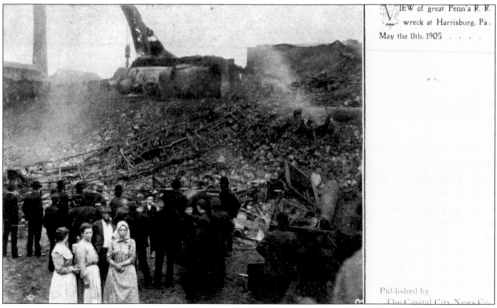

A strange recipe for disaster was waiting the westbound Cleveland express at 2:35 a.m. on Thursday, May 11, 1905, as it approached Harrisburg at Lochiel. A freight train loaded with dynamite was stalled on the tracks ahead when this devastating disaster occurred. The explosion was heard for miles, breaking thousands of windows. There were 75 killed and 100 persons injured. Shubert Theatre on Broadway in New York was named after Sam Shubert, who perished.

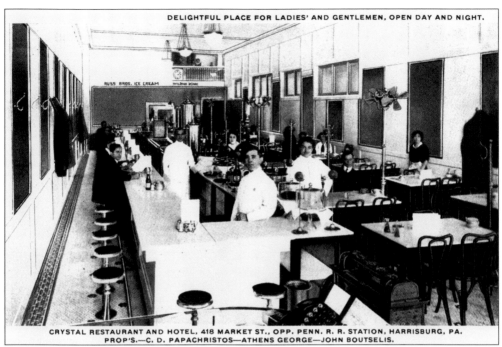

CRYSTAL RESTAURANT AND HOTEL, 418 MARKET ST., OPP. PENN. R. R. STATION, HARRISBURG, PA.
PROP'S.—C. D. PAPACHRISTOS—ATHENS GEORGE—JOHN BOUTSELIS.

Across from the Pennsylvania Railroad Station at 418 Market Street was the Crystal Restaurant. The efficient staff operated like clockwork getting out meals for travelers in a hurry. A specialty at this location was their baklava, made fresh daily. Being close to Pomeroy's Department Store was an added plus for business.

In 1872, the Masonic Hall was completed on the corner of Third and Walnut Streets. It anchored a large contingency of businesses across from the state capitol. This view was taken from the post office in the 1890s. In 1873, a large stage theater opened in this building, which became known as the Grand Opera House. It was the center of social events in the city until a fire destroyed it in 1907.

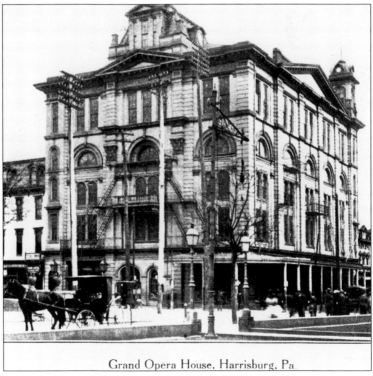

Grand Opera House, Harrisburg, Pa.

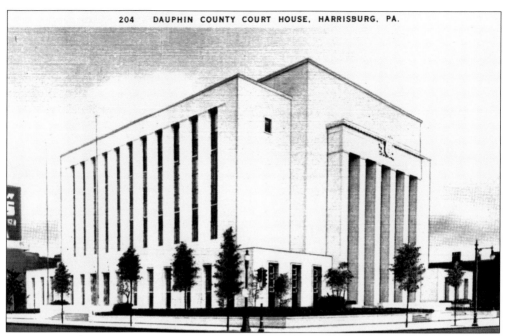

The new Dauphin County courthouse opened in 1943 on the high profile corner of Front and Market Streets, which is traditionally the most prominent entrance to the city. This neoclassical building is an interpretation of the art deco style. Clad in white Georgian marble, it represents a temple of justice. The interior depicts the history of Dauphin County through its decorative artwork.

On a Sunday afternoon in 1990, a photographer caught the city in transformation. A wide path of granite pavers has been lain near the train station and newly installed traditional lamp standards have been placed on the sidewalks. The old standby Pomeroy's Department Store is still holding its own. Many plans were in the making for these blocks on Market Street.

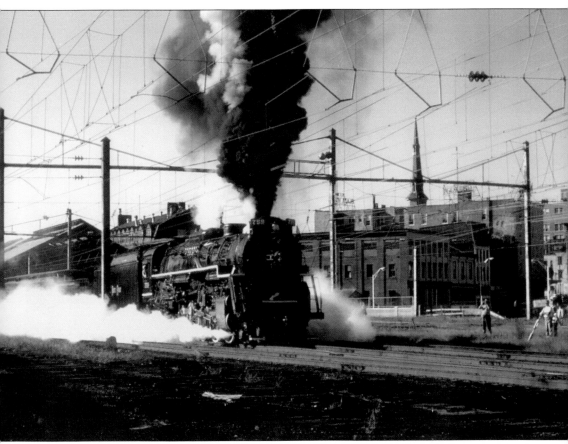

In a bygone era, a steam locomotive leaves the train sheds behind union station. The web of the electrical lines stretches above the smoke of the engine. The end of Walnut Street can be seen on the right. The spire of the Market Street Presbyterian Church towers beyond the plaza hotel. Steam-powered trains were the norm into the 1950s, when they were gradually replaced by diesel.

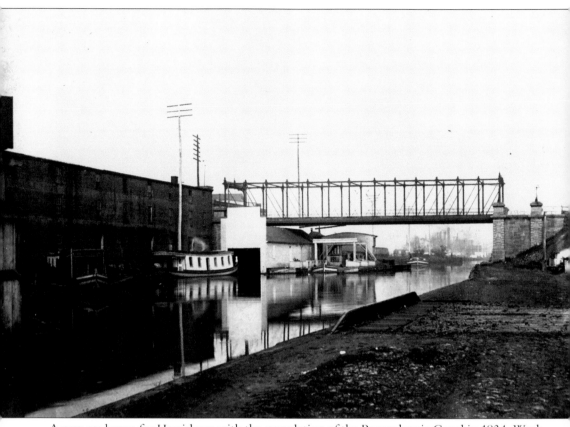

A new era began for Harrisburg with the completion of the Pennsylvania Canal in 1834. Work on this technological marvel began July 4, 1826, when Gov. John Andrew Shulze turned the first spade of dirt for lock No. 6 at the foot of Walnut Street. This project marked the beginning of Harrisburg's rise as a transportation center. The canal carried both goods and passengers, which guaranteed local manufacturers an outlet for their products. It also brought necessities and luxuries to town. From the beginning, Harrisburg was headquarters for the eastern division. Local business also profited because of the number of people brought to Harrisburg that had to wait to make connections. They took advantage of hotels and shopping. The canal's days were numbered though. Development of the locomotive soon overtook canal business, and Harrisburg entered its next phase of economic growth, railroading. This 1898 photograph shows various canal boats lined up with an iron bridge carrying Walnut Street over the waterway. The canal was abandoned in 1901 and eventually filled in.

Five

LET'S GO UPTOWN

Prior to the Civil War, Harrisburg was already outgrowing its northern boundary at Herr Street. The success of the Pennsylvania Canal, and development of the railroads drew newcomers seeking employment. Recent immigration caused the city to increase its population. At this time, owners of tracts of land north of the capitol advertised building lots for sale. The Second Reformed Church at Verbeke and Green Streets was located in this new district.

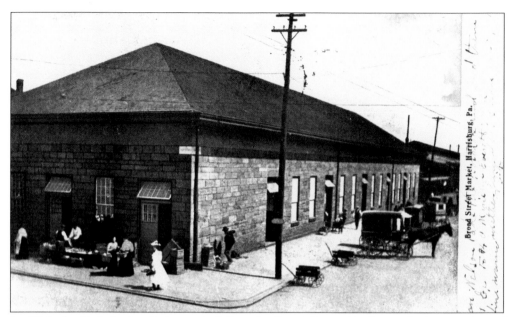

In 1856, the Verbeke family began building the Broad Street Market at the intersection of Third and Verbeke Streets at midtown. This enterprise eventually grew to cover more than two city blocks. It would also spur the growth of a thriving business district on Third Street. It is considered the oldest continuously operated farmers market in the country. Note the children's wagons. For a penny, one could have groceries delivered.

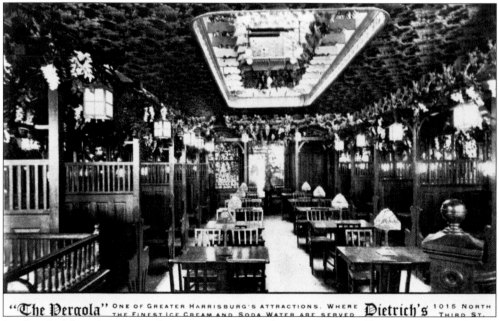

During the Victorian Era, a trip to an ice cream parlor was a memorable experience. Elaborate settings were crafted based on a specific theme. A. B. Dietrich, a popular caterer, created an intimate garden setting at the Pergola, located at 1015 North Third Street. He promised "full satisfaction with every order . . . no matter how spectacular!" The success of many social affairs in the city could be credited to Dietrich.

Looking down Third Street from the market can be seen many of the businesses of midtown. The market boosted the economic growth of this district. Every type of pursuit that one would encounter down near Market Square was now north of the capitol. With the improvement of the street rail system, people from all parts of the city came here to shop. Eventually the commerce would stretch north to Maclay Street.

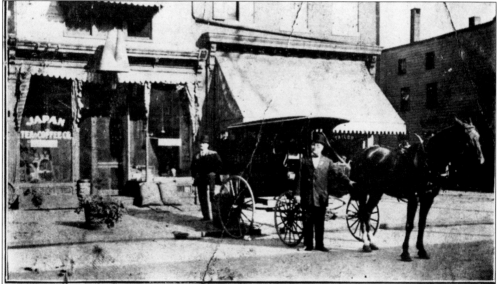

Located at 308 Broad Street, facing the market, the Japan Tea and Coffee Company was one of a number of specialty shops that operated near Verbeke Street. The owner was guaranteed to have a large roaster operating at all hours. The aroma alone was sure to attract customers. Many shops catered to the growing ethnic groups from central and Eastern Europe. Alsadek's, a Greek eatery up the block, was in business for generations.

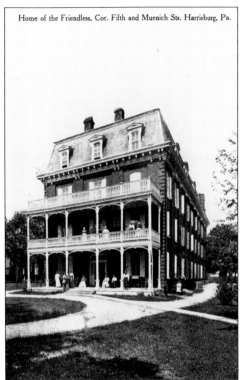

Home of the Friendless, Cor. Fifth and Muenich Sts. Harrisburg, Pa.

In the wake of the Civil War, representatives of nine city churches convened at Market Square Presbyterian to consider what could be done to help the forlorn of Harrisburg. Newspapers had noted the increased number of ragged children in the streets, not to mention the many women recently widowed without support. A society formed to raise funds. In 1871, this magnificent house was opened at Fifth and Muench Streets.

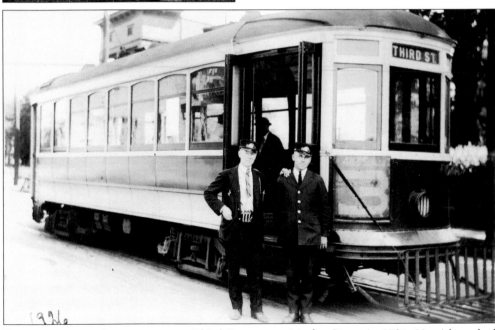

Two streetcar conductors pause on Third Street near Maclay Street in 1926. Harrisburg had an extensive system of street rails. Service reached all sectors of Dauphin County. This was expanded to include most West Shore communities. Later renamed Harrisburg Traction Company, automobile proliferation eventually caused the decline in ridership. Busses began a progressive replacement of trolleys in the late 1930s. Note the "people catcher" attached to the front.

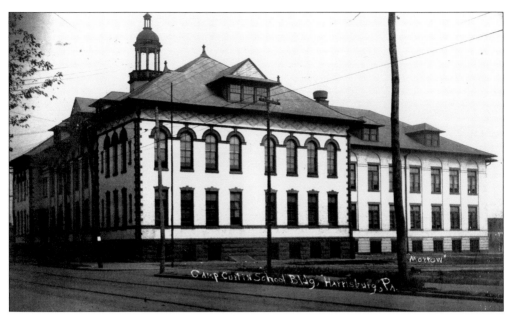

Another lucrative business district developed further uptown at Sixth and Maclay Streets. Known as Camp Curtain, it took its name from the important Civil War induction installation that was located in the fields north of Harrisburg at this location. The largest facility of learning in the city, Camp Curtin School was built here. Banks, churches, and many stores were located on Sixth Street, which had been called Ridge Road in the past.

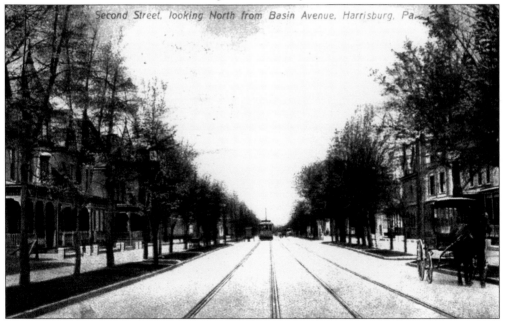

Harrisburg was incorporated as a city in 1860. The population increased as the manufacturing base and rail activity gained momentum. By 1880, 18,000 more people called Harrisburg home. The pressing need for housing in the subdivided areas to the north brought forth builders in a frenzy of development. North Second Street, serviced by the new electric streetcars in 1891, had been laid out in unified building groups.

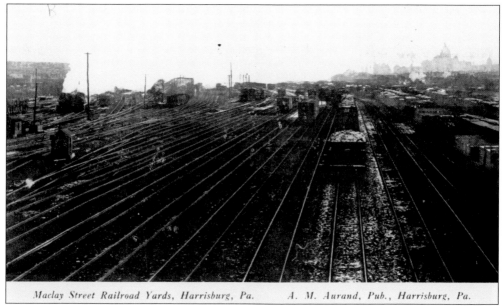

Maclay Street Railroad Yards, Harrisburg, Pa. *A. M. Aurand, Pub., Harrisburg, Pa.*

From the area of the bridge on Maclay Street looking south toward Capitol Park, the great Pennsylvania Railroad classification yards can be seen. Considered the largest such operation in the world, boxcars were efficiently assembled to form trains and then assigned to a particular locomotive. On any given moment, any package or container shipped by rail could be located through a sophisticated tracking system that the railroad had devised.

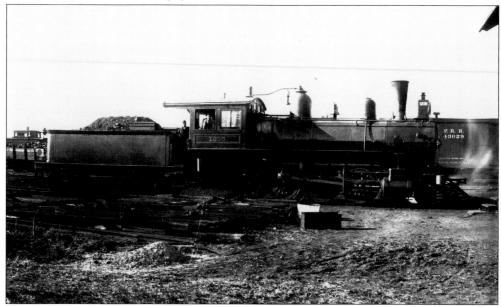

A photographer was at Harrisburg Yards in 1888, where he captured this freight locomotive and tender. This is No. 1235, built by the Pennsylvania Railroad in 1886 at the Altoona shops. The Pennsylvania Railroad bought Baldwin locomotives from Philadelphia; subsequently they began to manufacture their own world-class workhorses. Harrisburg had shops to construct passenger cars, a repair facility, two large round houses for changing the direction of locomotives, and a repair department.

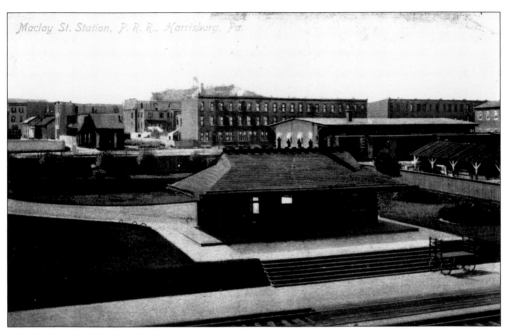

The Pennsylvania Railroad installed a station at Maclay Street in 1892. This new model was what Pennsylvania Railroad termed a suburban design and became a standard across the country. With this terminal, further building activity was spawned. A series of utilitarian row houses were created half a block away, interspersed with the older Queen Anne–style homes that had dominated the northern frontier of the city.

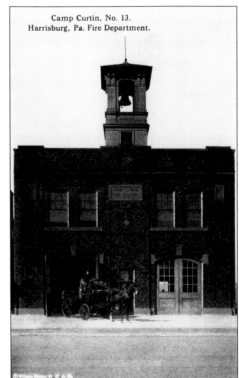

As the city grew, the need for fire protection followed pace. Camp Curtin was over a mile to the nearest fire station. In 1911, this permanent home was built at 2504 North Sixth Street. Their first priority was to build a cupola and secure a bell. A 1,000-pound bell was obtained by public subscription. The bell was used until 1968 when civil unrest caused the disuse of tower bells.

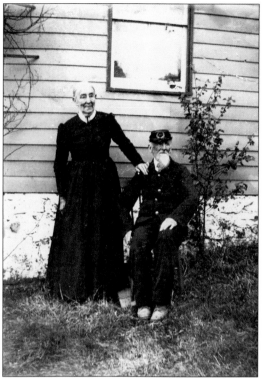

This Union veteran marks his 40th wedding anniversary. He greets a comrade on reverse reminiscing about their days at Camp Curtain and the ensuing chaos of conflict. He chides his old friend to visit as promised, and they could see new capitol that "ever body keeps fussin' bout." Incidentally Camp Curtin was a mustering site for over 300,000 Union soldiers and maintained one of the North's most important war hospitals.

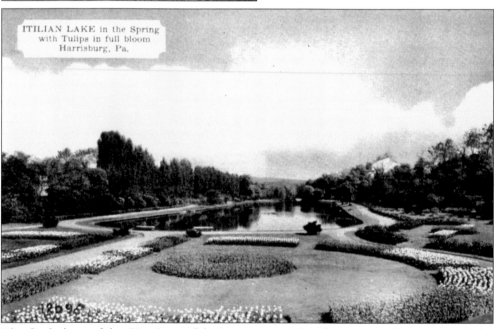

ITILIAN LAKE in the Spring
with Tulips in full bloom
Harrisburg, Pa.

The final phase of the City Beautiful Movement in Harrisburg was culminated with the development of the Italian Lake section of the city at Division Street. Wooded wetlands to the north were fed by springs. A traveling lodge on North Front Street was known as the "Italian Hotel." The name became associated with the nearby woodlands. The area was drained, and the springs were contained in pools, lagoons, and landscaped streams.

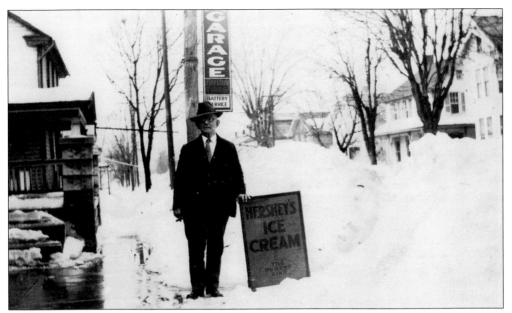

A proprietor of a combination service garage/grocery store above Division Street took in stride the day of one of Harrisburg's famous winter storms. With snow piled in the street over four feet from the shoveled sidewalks, he was going to have no vehicular business on this day in 1928. He dealt with it, digging out his Hershey's sign and planting it firmly in front of the white snow.

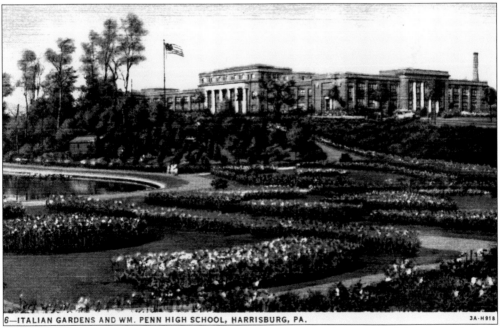

6—ITALIAN GARDENS AND WM. PENN HIGH SCHOOL, HARRISBURG, PA. 3A-H918

As early as 1903, the ground above Division Street was pegged as a part of the comprehensive plan of parks improvement. However, it would not become a reality until the 1925 construction of William Penn High School. Attention was drawn to this tract, and the support for the quality of the planned development fell into place. Fortunately the excavated earth from the school could be used extensively for park grading.

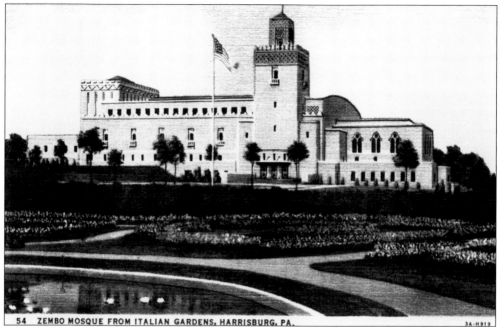

54 ZEMBO MOSQUE FROM ITALIAN GARDENS, HARRISBURG, PA. 3A-H919

The north end had been transformed into a place of beauty and prestige. It was only fitting that when Harrisburg's prolific architect Charles Howard Lloyd began to design the Zembo Shrine Temple, this Front Street and Division Street corner would be its home. The Zembo Masons sought a building that would set them apart from other organizations. This spectacular art deco structure surpassed this goal. As a public auditorium, it has gained international fame.

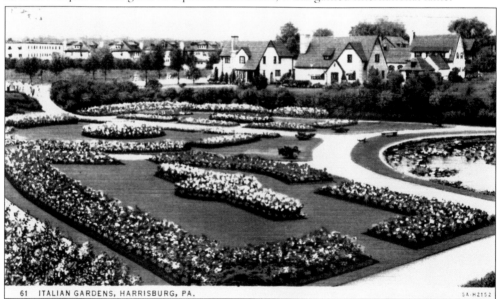

61 ITALIAN GARDENS, HARRISBURG, PA. 5A-H2152

Between the years 1925 and 1939, Italian Lake and its formal gardens would gradually transform from marshland to an exquisite place of beauty. This once isolated corner of the city now became an anchor for a growing community. Builders were now mapping out Harrisburg's next annexation. Division Street was no longer the edge of the city, but a beautiful drive between uptown neighborhoods.

84

Six

THE HILL DISTRICT AND BEYOND

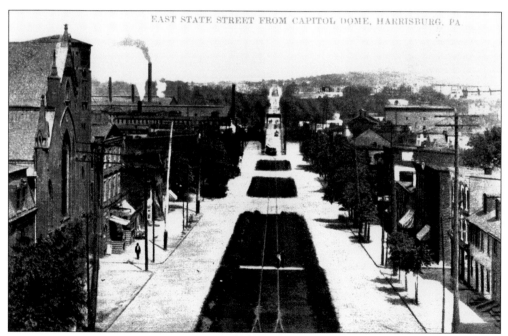

A view from the old capitol looking east shows State Street slicing through the old eighth ward. This neighborhood dates back to about 1808 and was outside of the Harrisburg Borough. Known as Maclaysburg, this thriving hamlet was incorporated into Harrisburg Borough in 1838 along with Capitol Park. An old State Street bridge climbs toward Alison Hill with two side ramps descending to the industrial area of Cameron Street.

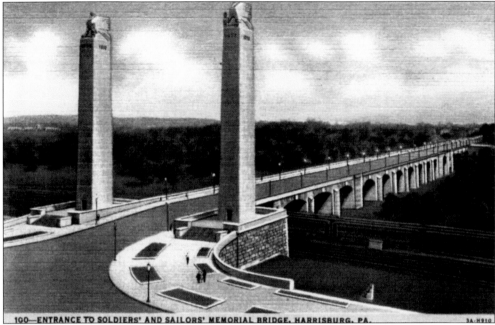

100—ENTRANCE TO SOLDIERS' AND SAILORS' MEMORIAL BRIDGE, HARRISBURG, PA. 3A-H910

The eighth ward was dismantled, and a spectacular entrance to the city from the east was realized with the completion of the State Street Bridge in 1930. Known as the Soldiers and Sailors Memorial Bridge, it was dedicated as a tribute to participants in all wars. It complements one of the most aesthetically important boulevards in the Pennsylvania. Designed by Lee Oskar Lawrie, it is flanked by towering pylons.

Seen from a passing Pullman car, a towering pylon is capped with its stylized eagle. It looks toward the capitol through Fisher Plaza. On the side of the monument is the year 1812. The overhead wires are for electrified trains. In the 1930s, when the Pennsylvania Railroad unveiled their mighty GG1 fleet, Harrisburg became the terminus of electric power. To this day, Amtrak trains traveling west switch to diesel at Harrisburg.

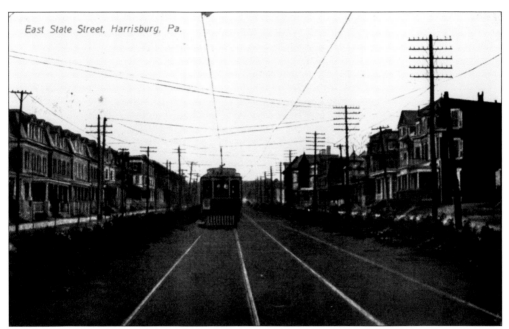

A street car advances up State Street on this twin track system. The growth of the hill district was accelerated by the laying of tracks into the neighborhoods. The population of Harrisburg continued to grow. Newcomers were attracted to the larger homes on the hill with convenient transportation. State Street was one of the few streets that had a green area designated strictly for the streetcars.

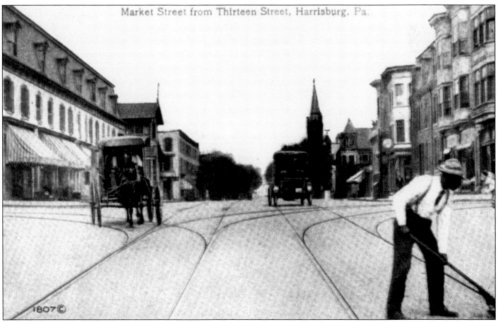

Market Street from Thirteen Street, Harrisburg, Pa.

Shown here is daybreak at the crossing of Market Street and Thirteenth Street. The street sweeper is out with his shovel and wheeled bucket. A single-horse delivery wagon is on its way to market. An early automobile has just passed. When this image was created, traffic signals and signs were not considered important. The businesses on Market Street extended far up the hill.

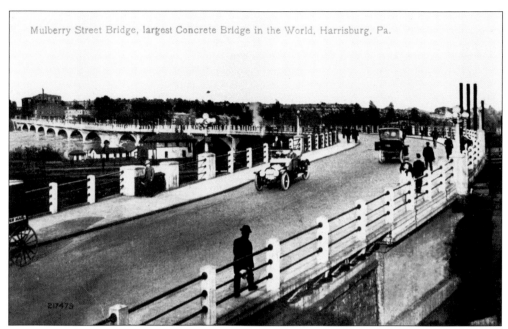

Mulberry Street Bridge, largest Concrete Bridge in the World, Harrisburg, Pa.

Mount Pleasant, also known as Allison Hill, sits on a bluff overlooking the city of Harrisburg. This bucolic area experienced growth with a spur rail line in the 1880s. In 1889, steel girders were strung from Harrisburg's downtown with iron railings and a wooden deck. Connecting Mulberry Street with the hill, this bridge was dubbed the "great unifier" since it brought old Harrisburg to the new districts. The whole affair went up in a spectacular fire in 1907. Work began at once on what would be the largest concrete bridge in the world in 1909. Harrisburg took to the dramatic structure immediately. It became a popular promenade for automobile traffic as well as those on foot. The postcard view below is taken from the hill looking over Harrisburg's southern industrial corridor and rail yards.

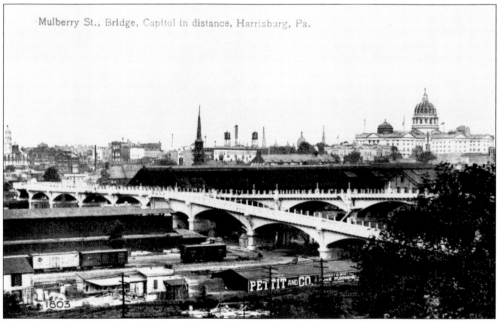

Mulberry St., Bridge, Capitol in distance, Harrisburg, Pa.

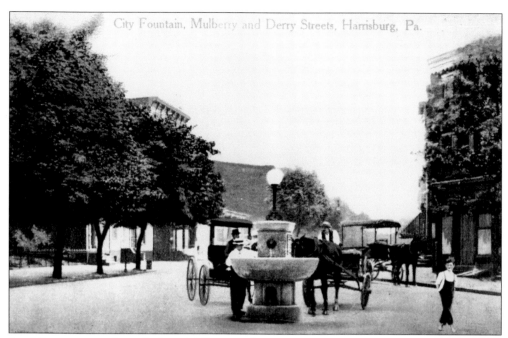

A public square was formed where Mulberry and Derry Streets crossed. Pleasant, well-kept homes and shops were located here. Derry was an important street for crossing the county. The city placed a public fountain at this square. A fountain promised fresh water for the horses and Fido had his spout down below. Some folks without running water at home depended on this outlet.

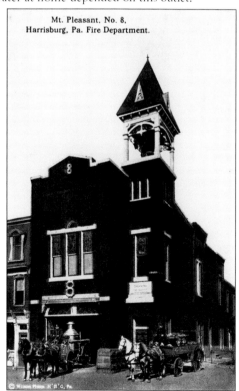

Mt. Pleasant, No. 8,
Harrisburg, Pa. Fire Department.

The Allison Hill district of East Harrisburg was annexed to the city of Harrisburg in 1869. The need for fire protection was answered when a group of spirited citizens banded together. In 1883, this single bay structure was built at Thirteenth and Howard Streets for the Mount Pleasant No. 8 firehouse. In 1887, a powerful steam engine pumper was purchased, shown on the left. On right is their hose and chemical wagon.

89

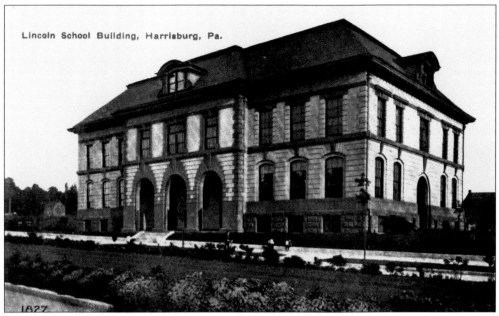

Lincoln School Building, Harrisburg, Pa.

1827

As neighborhoods grew in the late 19th century, an effort began to consolidate the numerous small schools scattered across the city into larger multi-grade facilities. Lincoln School at 1601 State Street was one such new school. Schools now provided courses that could prepare students for further education after graduation. Lincoln School had an added benefit with street rails passing its front entrance. Now expanded, this original building still serves the community.

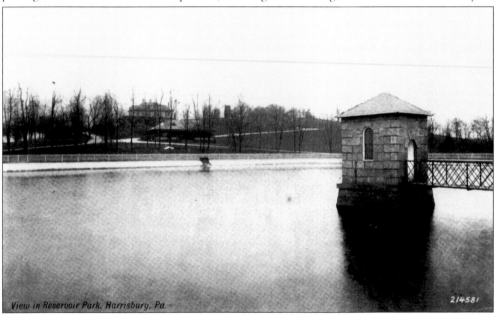

View in Reservoir Park, Harrisburg, Pa.

214581

Harrisburg's largest municipal park occupies 85 acres on Allison Hill. This highest point in the city has a wonderful vantage point to view the state capitol, the Susquehanna Valley, and the Blue Mountains. Originally called Prospect Hill, Reservoir Park dates to 1845 as a retreat. This site was chosen when Harrisburg moved the original water shed from North Street, next to Capitol Park, to the hill district in 1872.

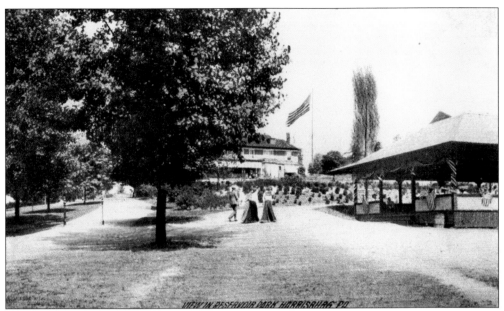

In the 1890s, the popularity of Reservoir Park caused increased development and was officially designated as a park. Since then many popular outdoor festivals and performances take place here. A band shell was later built. The National Civil War Museum completed the picture in recent years. The park is a part of the Capitol Area Greenbelt, a 20-mile greenway surrounding portions of the city.

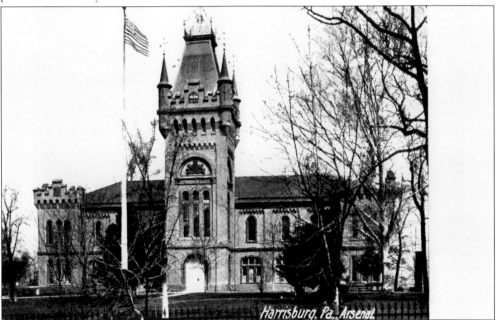

In 1817, the first arsenal was constructed at Third Street, just south of where the capitol would be built. This arsenal served through the Civil War. In 1874, land was chosen at Eighteenth and Herr Streets, a more spacious setting. The Pennsylvania State Arsenal was constructed in the Chateauesque style with an imposing central tower. The building was later modified and still stands. The fence is from the old capitol building.

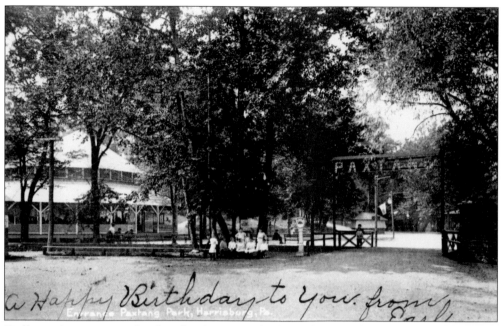

A Happy Birthday to you from Earl

Entrance Paxtang Park, Harrisburg, Pa.

Trolley parks were once developed to increase ridership. The Harrisburg Railways established Paxtang Park as its terminus in 1893. This 40-acre park extended from Derry Street to Paxton Street along Spring Creek until 1929. Included were a zoo, lake, picnic grove, and a vaudeville theater. Amusement rides included two popular roller coasters and its signature carousel. A residential community grew at this sylvan location and was incorporated as Paxtang.

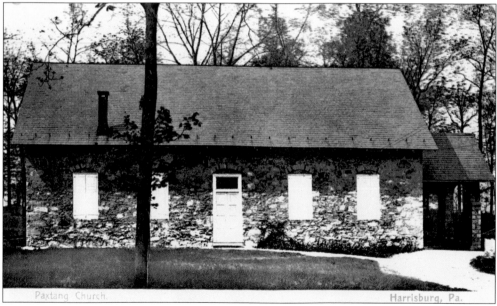

Paxtang Church. Harrisburg, Pa.

East of Harrisburg is an old stone church erected in 1740. Known as Paxtang Church, it replaced a log meetinghouse dating to 1716. When pioneers arrived, this area had been a Native American settlement for ages. The church became an important part of the regional culture. Its early history is closely interwoven with the colonial history of central Pennsylvania. Several noted statesmen and soldiers are buried in the churchyard.

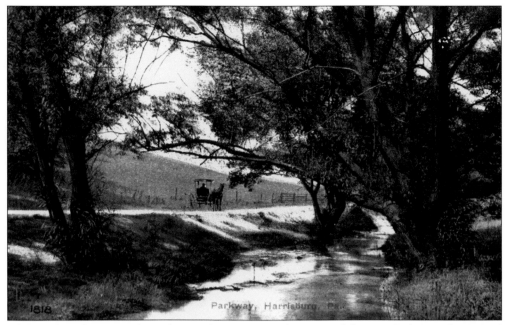

This is a bucolic image from the era that preceded the automobile. Roads during this period were not under state jurisdiction. Usually just a dirt path, they could become impassable after a storm. They were, however, maintained by farmers or draymen needing a means to get their products to market. Even after the automobiles were introduced, it would be a number of years before the state took responsibility.

Harrisburg's link to New York, Highway 22 was known in the 1930s as one of the fastest routes traveled. Shown after 1945, it had been upgraded to a four-lane super highway. Pennsylvania led the nation in highway building. The "Highway State" put many unemployed workers on road gangs in the depressed 1930s. The 1940s celebrated the turnpike's opening and the upgrading of many road systems across the commonwealth.

Chef's Paxtonia Inn, Paxtonia, Pa.
(R. D. # 4, Harrisburg, Pa).

CHEF'S DINNERS

5½ Miles East of the State Capitol :: Route 22 (Formerly 43) :: The Short Route to Allentown and New York

With over four cross-state highways established in Pennsylvania by 1930, many older homes were converted to business establishments. Some became roadhouses or taverns. Others were large enough to convert to inns. The Favinger family built cottages and transformed their family property into a popular inn at Paxtonia. Family-style meals were available starting at 75¢.

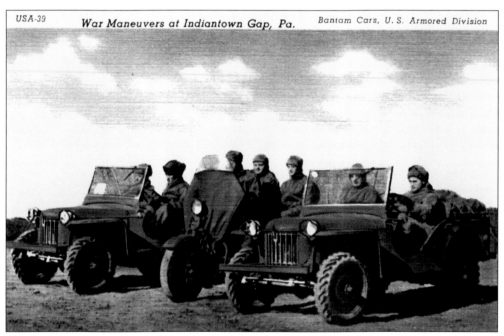

USA-39 *War Maneuvers at Indiantown Gap, Pa.* Bantam Cars, U. S. Armored Division

The federal government leased Fort Indiantown Gap during World War II to train seven army divisions bound for Europe. This Pennsylvania National Guard installation was the setting for a demonstration of a new vehicle in 1940. Banatm Cars, manufactured in Butler, were on hand for inspection. The army eventually ordered thousands of these. This rugged terrain traveler is said to have been named after the mystical character in the popular *Popeye* series, Eugene the Jeep.

94

Seven

DAUPHIN NORTH

A Scene in Cameron Extension Park, Harrisburg, Pa.

Anyone who is familiar with the highway leaving Harrisburg going north from Cameron Street would scarcely recognize the image shown. This unpaved single-lane path crossing a meadow cannot begin to compare to the multi-lane interstate highways with their interchanges and elevated cloverleaf built in the second half of the 20th century.

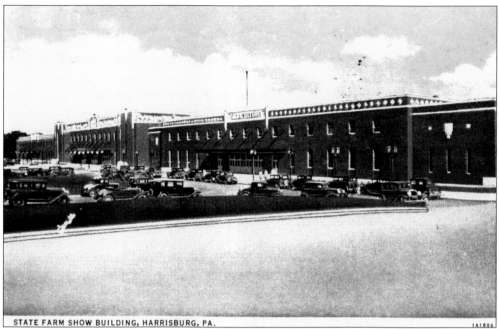

STATE FARM SHOW BUILDING, HARRISBURG, PA.

The journey out of Harrisburg begins at the corner of Maclay Street and Cameron Street. Here can be found the Farm Show Complex. This building houses the largest indoor agricultural event held in the United States. Expanded over the years, it holds 25 acres of display area and schedules 200 shows yearly. The Farm Show, a January event, is the equivalent of Pennsylvania's state fair and dates to 1917 at this spot.

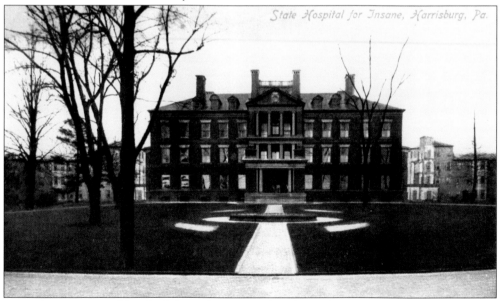

Located on 130 acres of farmland above the corner of Maclay and Cameron Streets, Pennsylvania's State Hospital for the Insane was opened in 1851. General thoughts at the time held that order in life helped to improve one's mental state. Buildings were grouped on symmetrical pathways. The campus was attractive and well maintained. It resembled more a large private school of learning than a medical institution.

96

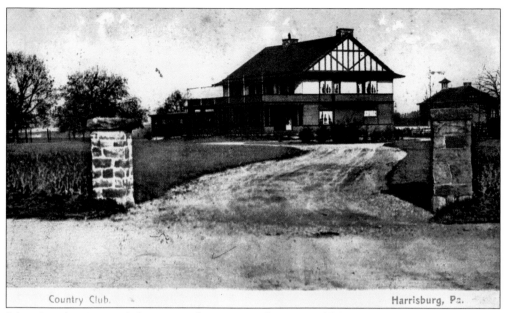

Country Club. Harrisburg, Pa.

River Road going north from Harrisburg originally was an old dirt trail along the Susquehanna River. As the city grew, Front Street claimed more of River Road. Harrisburg Country Club was built around 1900 on River Road and maintained attractive grounds. The lodge here had excellent banquet facilities, and many a bride was received here after her wedding. By the mid-20th century, River Road had many motels and eateries along this route.

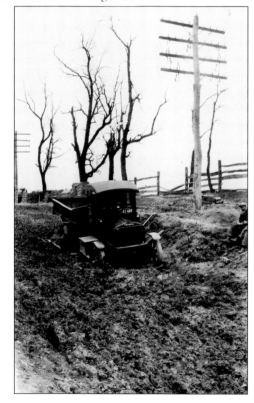

A legendary figure in Pennsylvania politics was Gov. William Cameron Sproul, serving from 1919 to 1923. One of his missions was to improve roads for the commonwealth. He had studied the highway situation as a state senator pushing legislation that led to a mammoth road building program. Photographs such as this, taken after a spring thaw, kept him informed of road conditions. He is regarded as the "father of good roads in Pennsylvania."

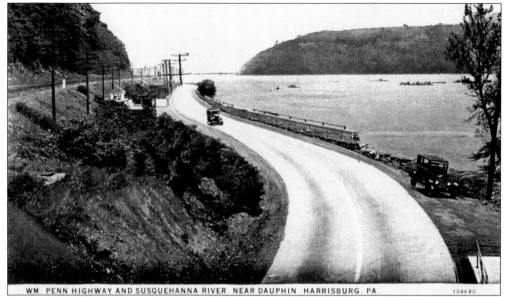

WM. PENN HIGHWAY AND SUSQUEHANNA RIVER. NEAR DAUPHIN. HARRISBURG. PA. 104690

The William Penn Highway followed the Susquehanna River toward Harrisburg. Proposed in 1916 as a roadway that would parallel the Pennsylvania Railroad across the state, it was adopted nationally as the final leg of the Pikes Peak Ocean to Ocean Highway continuing across Pennsylvania on to New York City. Harrisburg found it an advantage to have this paved route cross through the city. Note the little gas station on the left.

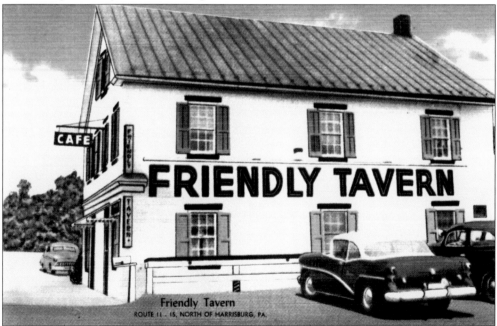

Friendly Tavern
ROUTE 11 - 15, NORTH OF HARRISBURG, PA.

Roadhouses are cultural icons in American society. These roadside getaways that dotted the highways on the outskirts of towns were an after work diversion. With their jukeboxes and neon, folks could relax and unwind. A simple menu was the norm, along with jerky and a jar of kosher pickles on the counter to go with a draught beer. Friendly Tavern, north of Harrisburg, was one such place.

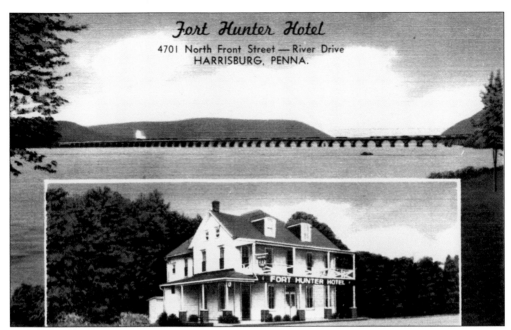

Fort Hunter Hotel

4701 North Front Street — River Drive
HARRISBURG, PENNA.

In the early days of motoring, before motels and cabins, roadside hotels were the place to stay when traveling. For generations, this building along the Susquehanna River was a familiar sight. From its porches, one of the best views in Pennsylvania could be seen. The wide river provided a spectacular vista with the full length of the Rockville Bridge in view.

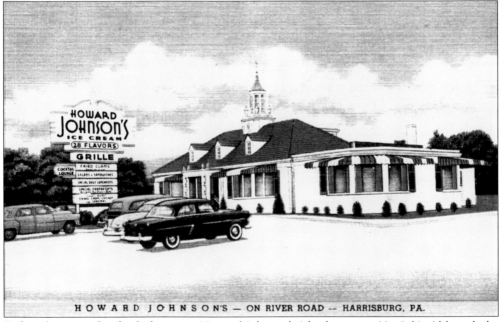

HOWARD JOHNSON'S — ON RIVER ROAD — HARRISBURG, PA.

Before there was fast food, there was Howard Johnson's (also known as Ho-Jo's). Although the restaurant had been around since the 1930s in parts of the country, Ho-Jo's became a part of the 1950s scene around Harrisburg. Here on River Road, the county extension of Front Street, they served their popular menu of home cooking that later became known to Americans as "comfort food."

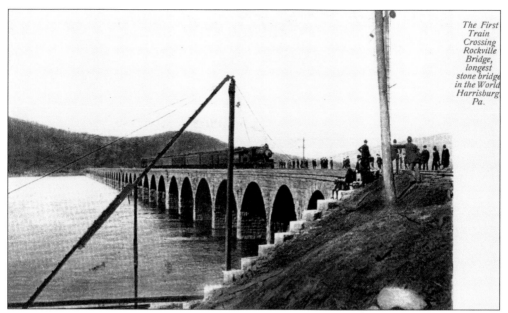

In 1889, the Pennsylvania Railroad began an upgrade across its system doubling its track capacity. Known as the "standard railroad of the world," Pennsylvania Railroad's construction projects were always big news. In April 1902, dignitaries were on hand at Rockville, north of Harrisburg, for the opening of the new Rockville Bridge. Shown here is the first train to cross this new four-track stone arch viaduct.

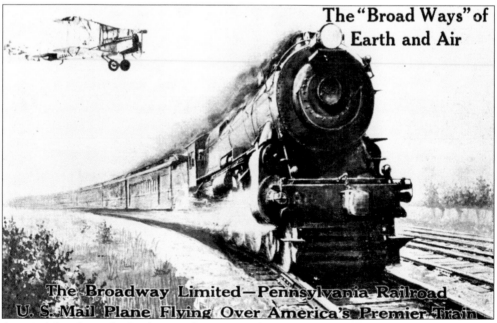

The "Broad Ways" of Earth and Air

The Broadway Limited—Pennsylvania Railroad
U. S. Mail Plane Flying Over America's Premier Train

America's hotel on wheels, the Broadway Limited stopped daily at Harrisburg on its run from New York to Chicago. Its maiden trip was in 1912, and the name was used until 1995. This card was produced in 1926 for the Sesquicentennial Exposition in Philadelphia. It says on the reverse, "New York to Chicago in 20 hours . . . a trip embodies the world's highest development in de-luxe, long distance train service."

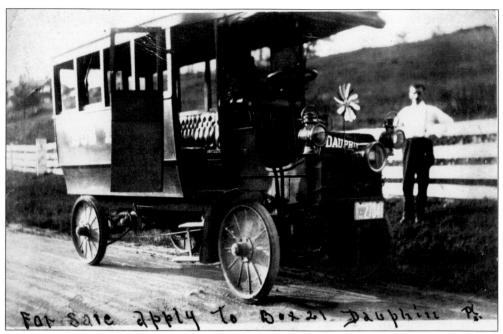

C. H. Welker of Dauphin found himself in dire straits in 1915. After sinking all of his savings into a fancy chain-driven omnibus, Harrisburg imposed jitney laws limiting his use of city streets. Welker distributed this postcard at filling stations and diners along the Susquehanna River. A note on the back offered it for $500. He implored those not interested to send it to someone who might wish to purchase.

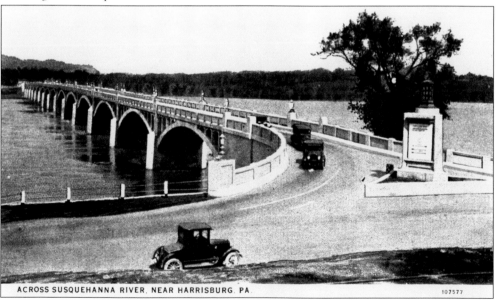

At Clarks Ferry, the William Penn Highway, Route 22/322, crossed the Susquehanna River on this concrete arch toll bridge constructed by prolific bridge designer Ralph Modjestki in 1925. He was also responsible for the Market Street Bridge a year later in Harrisburg. America's Appalachian Trail crossed the river here. A twin bridge ran perpendicular crossing to Duncannon on the opposite shore, creating a striking visage. The bridge was replaced in 1986.

Amity Hall, Junction of Wm. Penn Highway U. S. 22 and Susquehanna Trail, U. S. 11, at Clark's Ferry, North of Harrisburg, Pa.

Amity Hall is where the highways split. The great Juniata River Valley reaches its terminus here, flowing into the Susquehanna River. The road on the rights crosses the Juniata River to Duncannon, Pennsylvania, and the west shore. The road on the left shortly reaches the Clarks Ferry Bridge. This was an important stop on the Pennsylvania Canal. An inn stood here dating back to the 1800s.

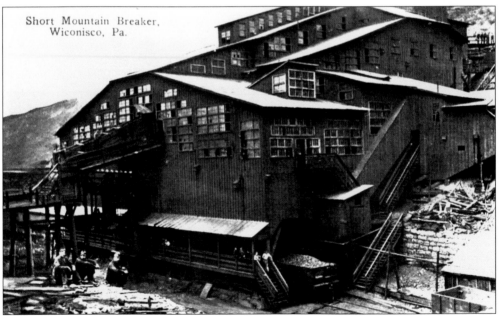

Short Mountain Breaker, Wiconisco, Pa.

Although it is not on the same route as the previous subjects in this chapter, the Wiconiscon coal breaker is worthy of mention. Located in the Lykens Valley of Northern Dauphin County at Short Mountain, coal was discovered here in 1825. The composition of this coal was very desirable. By the 1850s, nearly one million tons of coal was hauled from this vicinity on canal boats and by rail yearly.

102

Eight

THE WEST SHORE

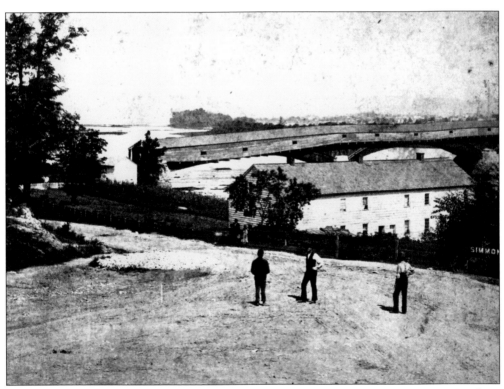

In 1718, John Harris established a trading settlement near the mouth of the Paxton Creek on the Susquehanna River. The West Shore became an immediate obsession. The ferry in 1733 led travelers westward. Consequently the riches discovered beyond that shore help to establish Harrisburg's infant economy. Shown here at Bridgeport, Cumberland County is the terminus of the Camelback Bridge on the West Shore in 1868. In 1905, Bridgeport became Lemoyne.

Founded in 1885, Camp Hill appeared to be rural, even into the 20th century. Paved roads crossed through passing large lots with few buildings. After World War II, an influx of people left Harrisburg. A building frenzy began that was to last for decades. Many corporate headquarters located here. It has become a desirable place to live. Ironically a duck breeding farm was once in its midst around 1910.

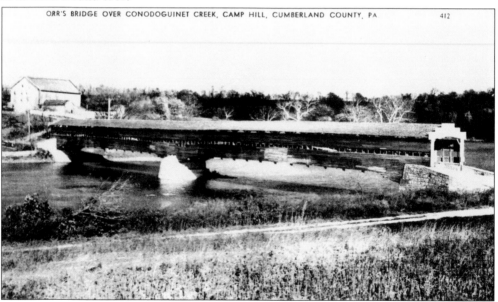

This magnificent structure once crossed the Conodoguinet Creek at Camp Hill. Orrs Bridge was one of the last of its kind still standing. At nearby Sporting Hill, the northern most engagement of the Civil War took place during the Gettysburg campaign of June 1863. The goal was to capture Harrisburg, but the enemy was forced to turn back after a skirmish. Harrisburg was two miles in the distance.

It is only fitting that a town known for its craftsmanship should have boasted such an attractive street fountain. Mechanicsburg was an important stop on the old Cumberland passage. Travelers going west found the mechanics that settled here specialized in repairing the Conestoga wagons that lumbered through from the Harrisburg crossing. Mechanicsburg later became an important stop that provided water for steam and fire wood to fuel locomotives.

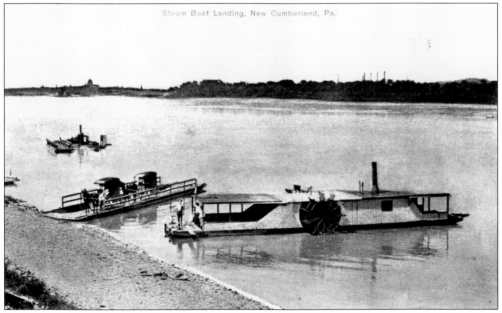

Transporting produce to Harrisburg markets from Cumberland and York Counties could be and arduous trek for a farmer. With this in mind, an enterprising individual established a steam boat landing at New Cumberland. The side-wheeler could pull a trailer barge complete with wagons and horses to Front Street in Steelton. This gave the farmers a scenic respite and also provided fresh fish from the Yellow Breeches to the Capital Region.

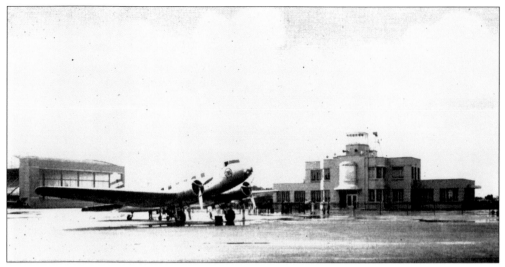

The Commonwealth of Pennsylvania purchased this field at New Cumberland for use as an airport. It served as a commercial field and was also important for military transports. In the early years, TWA was a major associate. Harrisburg was proud of its art deco terminal. In the late 1960s, Olmstead Air Force Base above Middletown became Harrisburg's international airport. This one, renamed Capital City Airport, continues an extremely busy operation.

The Valley Transportation Company began its journey at Market Square in Harrisburg. The cars lined up facing north, commencing to Walnut Street where they would cross the river on Peoples' Bridge. At the beginning of the 20th century, they commanded the route, but later the automobile vied for use of the roadway. At Wormlesburg, routes spread all over West Shore. A token from a ride is this 1930 transfer ticket.

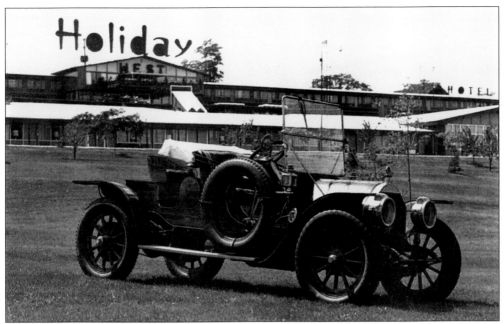

America's fascination with vintage automobiles has roots in the Harrisburg area. Since 1953, the Antique Automobile Association has been based in nearby Hershey. Shows and sales of special interest automobiles attract people from all over the country to Carlisle and Mechanicsburg. For years, nationally famous Gene Zimmerman displayed rare motorcars at his Automobilorama, History on Wheels, south of Mechanicsburg. Each month, Zimmerman released a postcard featuring a different classic.

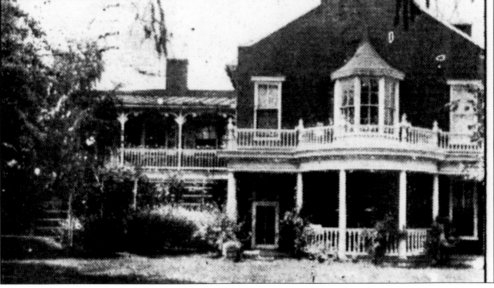

The state's most cosmopolitan governor made his home on New Cumberland's Market Square. John White Geary began his career as a teacher before becoming a Mexican War hero. He was first postmaster, then the first mayor of San Francisco during the gold rush. Offered the governorship of Utah, he chose that of Kansas instead. Geary also performed as a farmer, judge, a rail superintendant, and brigadier general during the Civil War.

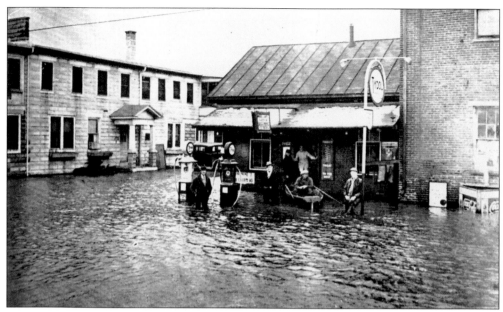

No event in recorded Pennsylvania history can top the devastation of the St. Patrick's Day flood of 1936. A harsh winter coupled with an early thaw caused rivers all over the state to crest as much as 24 feet. The Harrisburg area felt the brunt of this tumult. Here at the Tydol Station in New Cumberland, one of hundreds of skiffs pushed into emergency service pauses for a Coca-Cola.

On the edge of Harrisburg's sphere of tourism lies one of the country's most revered attractions. The Battle of Gettysburg was the bloodiest event on our shores. But, before the smoke cleared, people felt a need visit. The events of those three days in July 1863 continue to draw people. This early touring car seemed to be made for the battlefield. A photographer was always on hand to produce a personal memento.

The enterprising owner of the Mayflower Restaurant between Carlisle and Harrisburg thought of a novel way to advertise. Planes on approach to the Harrisburg airport at New Cumberland had full view of road house with it name painted on the roof. Once landed, hungry travelers showed up. It is also suggested that his menus were placed in the seat pockets of many flights. He specialized in sizzling t-bone steaks and chops.

Before the completion of Interstate 81, most regional traffic found itself going through Camp Hill. With the turnpike nearby, New Cumberland and Camp Hill had more of their share of motels. Flashy eye-catching signs boasting air-conditioning, swimming pools and television were on all sides. And, of course there were the ubiquitous diners. Camp Hill began developing into a shopping and restaurant mecca in the mid-20th century.

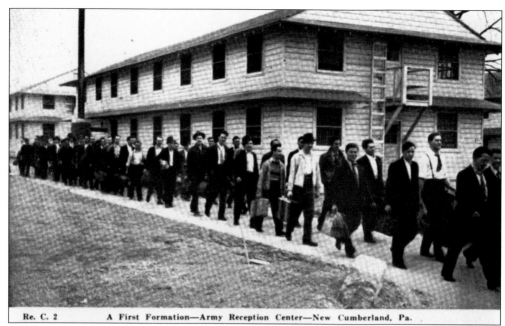

Re. C. 2 A First Formation—Army Reception Center—New Cumberland, Pa.

They came by bus and trains from all four corners of the state. Their first stop was Market Square where they queued for busses to New Cumberland. As in generations past, Harrisburg set the stage for a massive migration. Thousands of enlistees were inducted and given their orders at this massive processing center. After the World Wars, this depot would remain the largest defense distribution center in the country.

In October 1940, the country's first super highway opened west of Harrisburg. This relatively straight stretch of innovative concrete ran west to Irwin, 160 miles away. Changing the way all would think of travel in America, the Pennsylvania Turnpike was an immediate sensation. This highway had an impact on how engines were designed after the war and was a model for highways built throughout the remainder of the century.

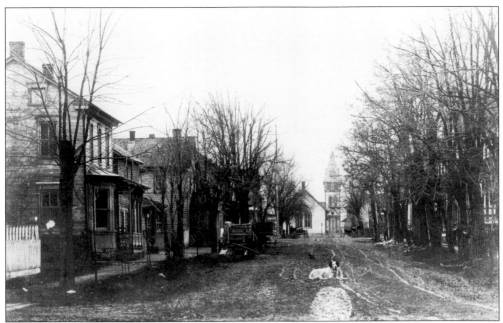

Marysville, incorporated in 1867, is a picturesque town on Highway 11/15 on the West Shore. It proudly claims the stone arch Rockville Bridge as its own. In this view, the town square can be seen as it leads down to the Pennsylvania Railroad rail yards. Most of the houses in the scene still stand. On this day, town mascot Clementine was keeping watch at her usual perch.

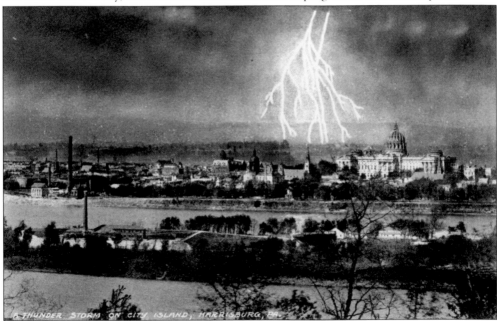

From a vista in Wormleysburg, Harrisburg is caught in a dramatic storm. Forks of lightning bolts illuminate the capitol. Boat houses can be seen on City Island. The filtration plant is shown from this angle, where the Harrisburg Senators would someday play. Along Front Street from left, one can see the old silk mill, the standpipe, and in the distance, Central High School and the church spires of State Street.

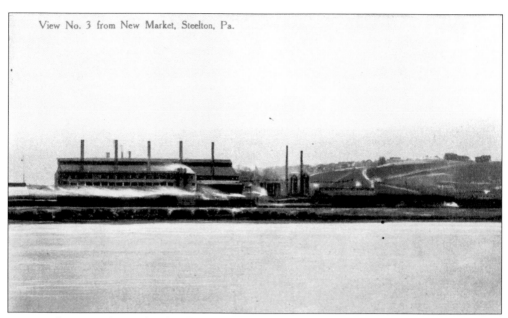

New Market is on the south side of the Yellow Breeches Creek from New Cumberland. It is in York County. If one were to stand on its shore in 1900, where the airport and the New Cumberland Supply Depot are today, they would have a glimpse of this view. Across the Susquehanna River is the sprawling steel plant in Steelton. Much of that borough was yet to be built.

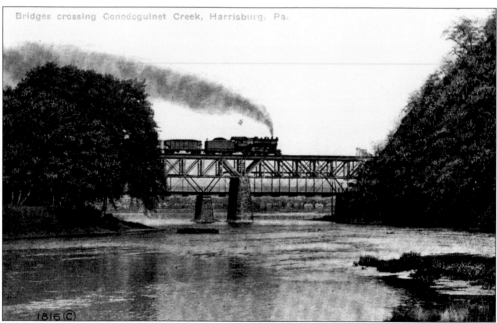

Bridges crossing Conodoguinet Creek, Harrisburg. Pa.

1816 ©

A locomotive wends its way across the fingerling loops of the Conodoguinet Creek on the Philadelphia and Reading Railroad. This was Harrisburg's southernmost bridge, until Route 83 south was completed in 1960. The iron trestle to the rear is the Cumberland Valley Railroad, which later was replaced with the concrete arch structure that stands today. This train is chugging toward the Susquehanna River.

Nine

Dauphin East, How Sweet it is

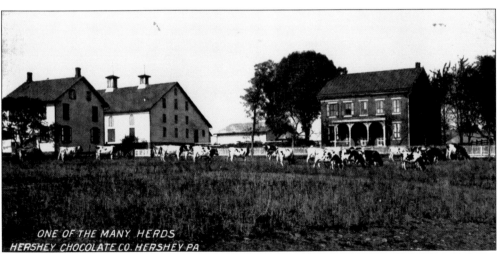

ONE OF THE MANY HERDS
HERSHEY CHOCOLATE CO. HERSHEY PA

The rich soil east of Harrisburg is the best farm land in the country. When Milton Hershey decided to try his hand at making chocolate, he knew he would have to have plenty of milk. Derry Township was the ideal place for his venture. He made chocolate available to the common man and inserted this desirable postcard, part of a series, as a candy bar liner beginning in 1910.

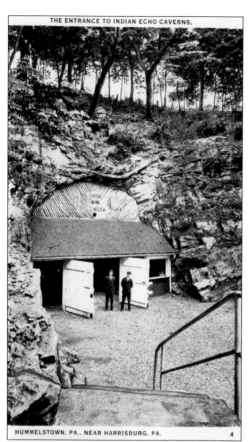

Because of the abundance of subterranean limestone in Pennsylvania, many "show caves" have been discovered within the commonwealth. Indian Echo Caverns can be found outside of Hummelstown. It is one of the most visited in the country. This roadside attraction became a popular attraction over 100 years ago when an entrance to this cavern was exposed. It became an immediate sensation.

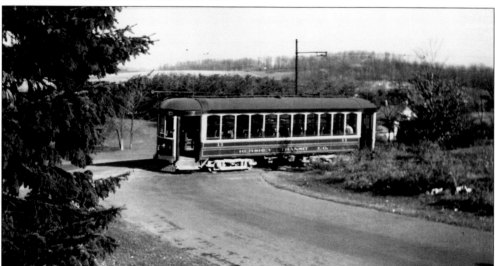

When Milton Hershey began assembling his chocolate empire, one of his priorities was to provide an efficient means for his employees to arrive at work. Consequently an interurban trolley system was constructed. Expanded to many communities, the use of this network became varied. Excursion cars were available to bring people to the park that he was building. During the week, milk cars hauled 50,000 gallons daily. This crossing is near Hummelstown, around 1945.

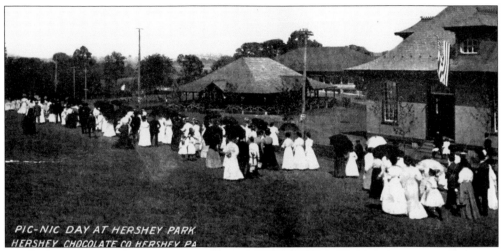

Another candy bar insert depicts a group that arrived via trolley on a picnic express. The transportation system had expanded throughout the county. At Market Square in Harrisburg, special excursion cars left for Hershey Park on the hour arranged by church groups, employers, and fraternal organizations. These were fitted to carry picnic lunches for a day's outing.

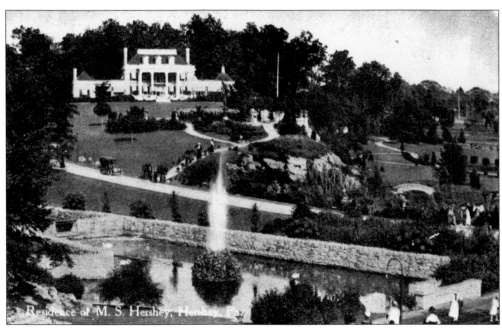

Hershey, born in Derry Church, made candy making his ambition. After failed attempts in three cities, he returned to Lancaster City and established a caramel company. Here he found success. He sold this venture and returned to his birthplace, building this house and the world's largest chocolate enterprise. He graciously permitted the public to enjoy the beauty of his estate.

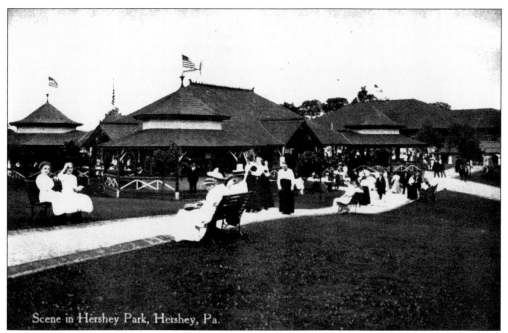

Scene in Hershey Park, Hershey, Pa.

With the idea of providing a calm spot of nature for his employees, Milton Hershey opened a park in 1907. Its original appeal was simplicity. Each year, Hershey added more attractions and enlarged his amusement park. Along with the original pavilions, he eventually added a ballroom, a convention center and a zoo. After an elaborate carrousel was built for him, mechanized rides followed.

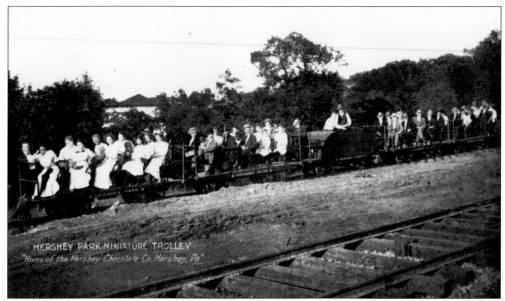

HERSHEY PARK MINIATURE TROLLEY
"Home of the Hershey Chocolate Co, Hershey, Pa"

In 1908, Hershey Park opened the season with an additional attraction. A scenic railroad had been built that traveled into the country side. This popular ride remained unchanged throughout its 60-year history. The park itself eventually grew to be one of the largest amusement parks in the country and has always maintained gardens and special plantings as a reminder of its original purpose.

Ten

POST SCRIPTS

When the last century was young, and the postcard was a new sensation, people communicated spur of the moment thoughts on a card. In the early years, the message was written on the front. Occasionally the whole image was obliterated with a message. When the rules changed, and the reverse could include a message, the postal service saw an instant increase in revenues.

Rc. C. 3 Processing and Clothing Issue Buildings—Army Reception Center—New Cumberland, Pa.

America became mobilized at the end of 1941. The greatest migration of U.S. citizens in history had begun. The destination was all corners of the world. Harrisburg felt the change. With its three draft boards and the induction center at New Cumberland, servicemen were a common sight in the city. Inductees were supplied with their clothing and processed for training and assignment at this facility.

A group of bobbysoxers on their way home from school hang out on Market Street in Lemoyne in 1942. One of the girls in the group named Rhoda mailed this card to her cousin in Bellwood. She talks about ordering her class ring and plans for attending an upcoming big game at New Cumberland on Saturday.

Old Home Week was a memorable experience for Harrisburg. It was a celebration of history, yet, it also was an event that drew attention to the positive changes taking place in the city. New bridges, parks and buildings pleased the visitors. This card was an invitation to the affair and depicts two views of the triumphal arch.

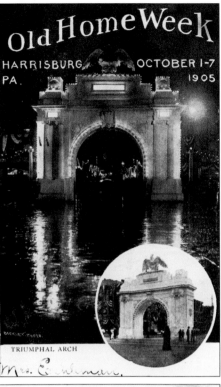

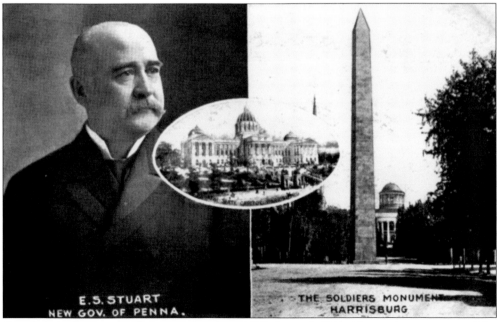

Gov. Edwin Stuart served as governor from 1907 through 1911. He stands out as one of the most honest and dedicated individuals to hold this position. Party members mailed out this announcement at the time of his election. The Soldiers' Monument photograph on the right of the card is from a prior generation, showing the old brick capitol building. Governor Stuart also served as mayor of Philadelphia.

For many years, the chief politician on Capitol Hill was not the governor. Nor was it an elected official. The know-it-all was Billy. Billy was a squirrel. All school children knew him, and editorialists would quote his thoughts on current issues. Billy seemed to have an opinion on all subjects, and he would switch party affiliations depending on who was doing the interview.

Few have seen this angle of the transportation center in downtown Harrisburg. While urban renewal changes were taking place a generation ago, a photographer snapped this from a nearby building at the end of a workday. This view gives a different focus on this grand building and its train shed.

120

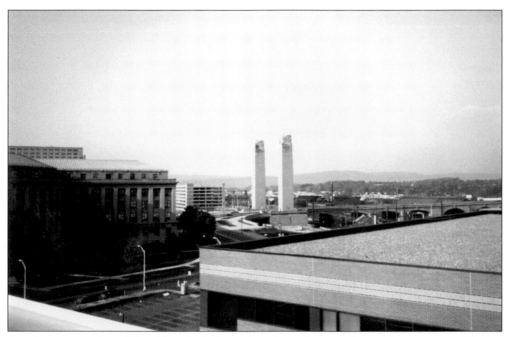

Another perspective of Harrisburg's skyline taken from the top of a parking garage on Market and Fourth Streets shows the view looking northeast in 1989. The two pylons of the Soldier's Memorial Bridge at State Street near Seventh Street stand guard over Fisher Plaza. Although they have stood almost 80 years, their design is timeless.

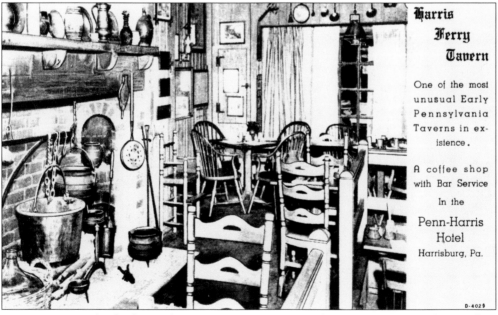

For many years, the food served at Harris Ferry Tavern in the Penn Harris Hotel was talked about all over town. But the atmosphere was equally memorable. The proprietor displayed an array of colonial artifacts to give it the feel of a period hostelry. Some of the items displayed were of local artisans. Harrisburg pottery, such as Cowden and Company, and period metal work is highly sought by collectors.

A proud Pennsylvania fireman poses with his full uniform. With boots and buttons polished, this public servant stands proudly for the camera. He has dressed for an honors banquet. On the back, it shows that he had mailed this card to his Aunt Edna in Shiremanstown in 1907. He tells her that he was inducted this evening and was presented with a pin. He signs it, "your nephew, Buddy."

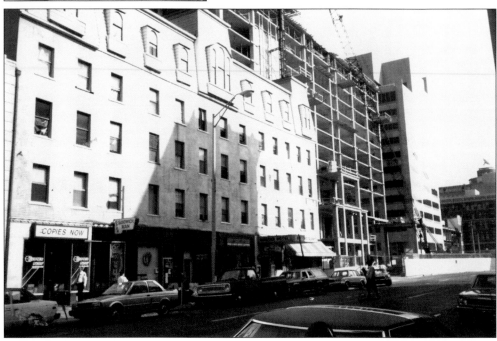

One of Harrisburg's last important business ties to the Federal period is shown. The former Bolton around 1990, now called the Warner, was on a list for demolition. A new skyline grows up around this survivor. Dating to 1812, it is the only original Market Square building still standing. The building on the right is the Hotel Hilton, under construction.

Looking up Second Street from Blackberry Street, the city is seen in transformation. The Hotel Hilton is taking shape. It has replaced a number of buildings. That spot at one time had people lined up to watch a movie or buy a newspaper. The Bolton can be seen beyond the construction equipment. New sidewalks and lighting as well as a sidewalk clock have been installed in advance of the new buildings.

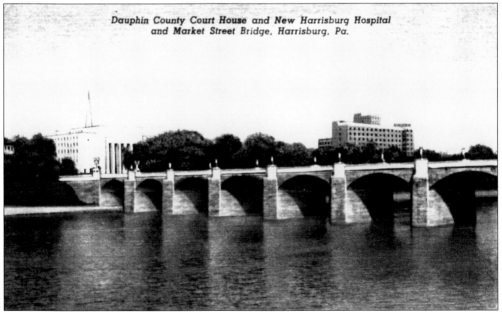

Dauphin County Court House and New Harrisburg Hospital and Market Street Bridge, Harrisburg, Pa.

On the Susquehanna River, the Market Street Bridge is shown around 1951. At the end of the bridge is the new Dauphin County courthouse on Front Street. Further down river at Mulberry Street is the recently completed Harrisburg Hospital. It ranked as one of the largest medical facilities in the state of Pennsylvania.

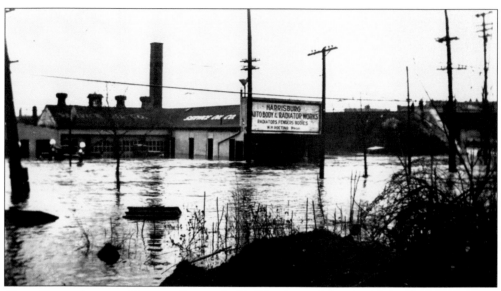

Above Paxton Street on Cameron Street, the Shell Station and the Harrisburg Auto Body works are taking the brunt of the 1936 flood. This flood was the costliest disaster on record, and its effects would be felt for years to come. By the end of 1938, the well-established interurban streetcar systems across the state found it impossible to replace damaged track and compete with the automobile.

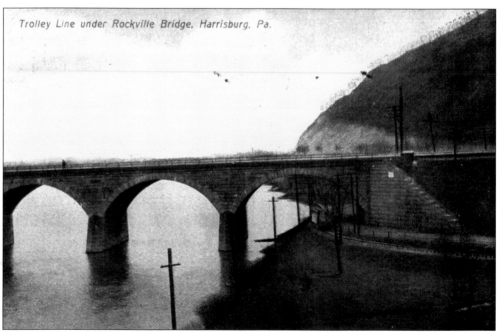

Trolley Line under Rockville Bridge, Harrisburg, Pa.

At one time, towns far removed from the centers of commerce were connected by a network of rails that covered whole counties. These were not large railroad conglomerates. They were companies that were many times private and existed because there was a vested interest in the service they could provide. Here a lone trolley skirts the Rockville Bridge on its way from Dauphin Borough.

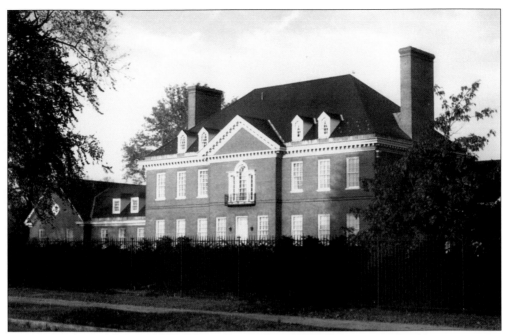

The old Keystone Hall served its purpose until 1960. The building was torn down for a parking lot and the governor commuted from Annville to the capitol. Plans were drawn up for a new mansion in 1941, but it was delayed by the war years. Finally in 1968, Gov. Raymond P. Shafer moved into this building on Front and Maclay Streets. This photograph was taken shortly after completion.

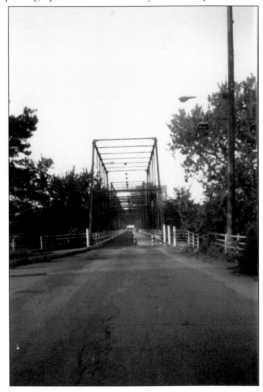

Prior to City Island being revamped in the late 1980s, it served the purpose of being a large parking lot. After work hours, it became virtually deserted. Both the Walnut Street Bridge and the Market Street Bridge have a section of roadway runs the length of the island. Shown here is the center of City Island in between sections of the Walnut Street Bridge.

On a Saturday afternoon in 1934, an excited crowd of youngsters waits to attend the premier of a Johnny Weissmuller Tarzan film. The matinee is part of the Capitol Theatre located at 7 South Thirteenth Street. Theaters during the Great Depression usually had token gifts for the attendees, which might explain part of the excitement. The Capitol Theatre was a movie palace that had an elaborate main portion that showed the "A" features. On this day, a Richard Barthlemess movie, *A Modern Hero*, was being shown. With the feature film, there might be a short film and both would be preceded by a newsreel and a cartoon or two. Thirteenth Street had a well-developed and popular shopping district.

Prior to Indiantown Gap's opening in 1931, encampments took place at nearby Mount Gretna. This 1920s photograph is credited to the author's great grandfather John Curtis Lee Tackitt. He served as a reservist from the Spanish American War through World War II. His father was a Confederate soldier who was wounded and held prisoner in Lancaster after the Gettysburg campaign. Tackitt was a photographer who developed his own photographs at home, showing up at picnics and church socials with his large tripod camera equipped with its black drape and bellows. Leaving school at age nine, he went into the mines of Centre County as a water boy. Yet he became an engineer with the Pennsylvania Railroad by completing a correspondence course on locomotive operations. A postcard and photograph collection that he compiled gave the author of this book an interest in the world of ephemera.

DISCOVER THOUSANDS OF LOCAL HISTORY BOOKS FEATURING MILLIONS OF VINTAGE IMAGES

Arcadia Publishing, the leading local history publisher in the United States, is committed to making history accessible and meaningful through publishing books that celebrate and preserve the heritage of America's people and places.

Find more books like this at
www.arcadiapublishing.com

Search for your hometown history, your old stomping grounds, and even your favorite sports team.

Consistent with our mission to preserve history on a local level, this book was printed in South Carolina on American-made paper and manufactured entirely in the United States. Products carrying the accredited Forest Stewardship Council (FSC) label are printed on 100 percent FSC-certified paper.

MADE IN THE USA